10 STEP DRAWING

Kawaii

Published in 2023 by Search Press Ltd.
Wellwood, North Farm Road
Tunbridge Wells
Kent TN2 3DR

This book is produced by
The Bright Press, an imprint of the Quarto Group,
1 Triptych Place, London
SE1 9SH, United Kingdom.
T (0)20 7700 6700
www.quarto.com

Reprinted 2023

ISBN: 978-1-80092-117-7

Publisher: James Evans
Editorial Director: Isheeta Mustafi
Art Director: James Lawrence
Managing Editor: Jacqui Sayers
Development Editor: Abbie Sharman
Project Editor: Polly Goodman
Design: JC Lanaway

Printed and bound in China

Kawaii

DRAW OVER 50 CUTE CREATIONS IN 10 EASY STEPS

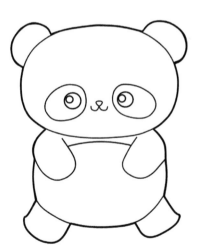

CHIE KUTSUWADA

Search Press

Contents

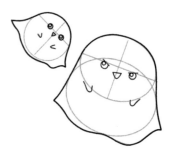

⋙ Kawaii Expressions

⋙ Kawaii Accessories

⋙ Kawaii Monsters

⋙ Kawaii Animals

⋙ Kawaii Birds

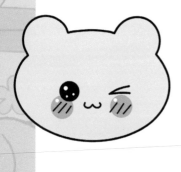
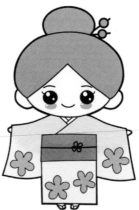

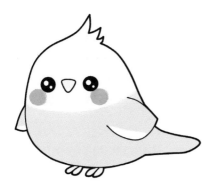

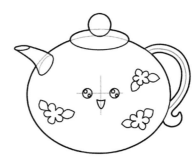

>>> Kawaii Fantasy

>>> Kawaii Food

>>> Tea Party

>>> Kawaii People

Introduction

In this book, you will find over 50 kawaii illustrations of expressions, fantasy characters, animals, food and accessories that have been created in just ten simple steps. Whether it's a flowery kimono girl, a spotty tea cup, or a pretty lovebird, it's time to choose your favourite kawaii project and get drawing!

Kawaii is the Japanese art and cultural style of cuteness, using simple line drawings, bright and pastel colours, and childlike, innocent characters.

6

TACKLING DIFFERENT SHAPES

Kawaii projects involve lots of different shapes. Each drawing in this book begins with a simple shape. The step-by-step instructions then use further shapes as guides for the rest of your drawing. This will enable you to get the proportions right, and to get just the right amount of cuteness applied to your people, animals and objects.

Following the instructions and guides on which shape each element should be will help you achieve the overall appearance of different characters and objects.

I have provided a colour palette at the end of each finished drawing. Use this as a guide, but feel free to experiment and use your favourite shades instead.

I hope you enjoy drawing the kawaii projects in this book as much as I did. Drawing has never been easier!

How to use this book

BASIC EQUIPMENT

Paper: Any paper will do, but sketch paper will give you the best results.

Pencil, eraser and pencil sharpener: Try different pencil grades, and invest in a good-quality eraser and sharpener.

Coloured materials: See the colouring options in the next section.

Small ruler: This is optional, but you may find it useful for drawing guidelines.

FOLLOWING THE STEPS

Use a light pencil to trace the shape guidelines in each step. Use a thin fineliner pen to ink the outlines, then a thicker pen to thicken the outlines. Erase the pencil guidelines. Finally, apply the colours of your choice.

Top Tip

Depending on your chosen materials, some colours may blend together as you build up colour in your drawings. To avoid this, use the lighter colours first, followed by the darker tones, or leave a white space for items like the cheeks. This will allow you to achieve the colour you want.

COLOURING

You have several options when it comes to colouring your drawings – why not explore them all?

Coloured pencils: This is the simplest option, and a good set of coloured pencils, with about 24 shades, is really all you need. Stay inside the lines and keep your pencils sharp so you have control in the smaller areas. To achieve a lighter or darker shade, try layering the colour or pressing harder with your pencil.

Paint and brush: Watercolour is probably the best paint to achieve delicate colouring. Acrylic will allow you to achieve pop and flat colouring, and you can paint over any mistakes. You'll need two or three brushes of different sizes, with at least one very fine brush.

Marker pens: Once you achieve the basic skills, markers are effective in achieving pop and flat colour.

White opaque pen: This is essential for adding highlights in the final steps.

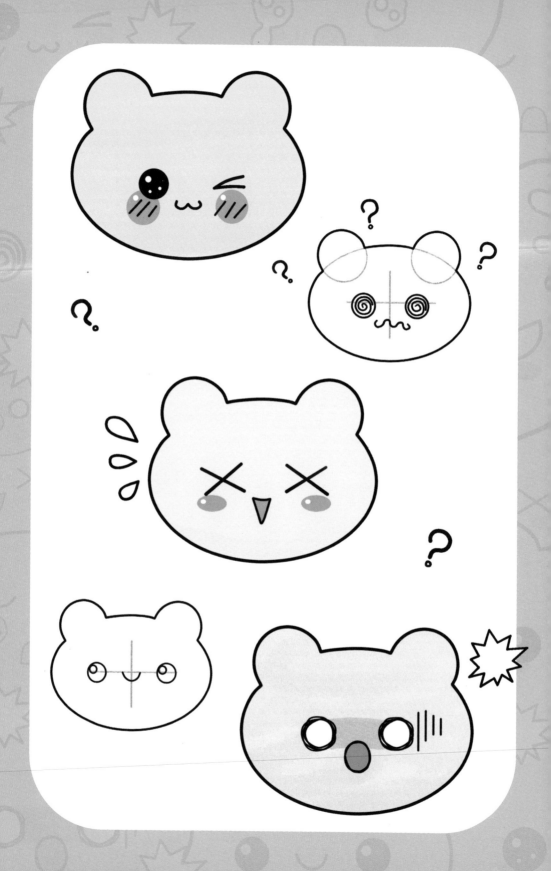

Kawaii Expressions

Smiling

Kawaii expressions are fun to draw – using just a few simple lines, you
can make a full face in minutes! Try this smiling face to start.

(1) Draw an oval for the
face and two circles
for ears. Add a cross
in the middle.

(2) Erase the areas where the
circles overlap to form the
outline of the head.

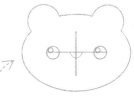

(3) Add two eyes spaced
evenly on the horizontal
line, with a smaller circle
in each for highlights.
Draw a U-shape for a
smiling mouth just below
the centre of the cross.

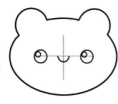

(4) Ink the outlines with
thick, smooth lines.

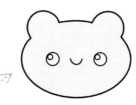

(5) Add a flat, even colour
to the face.

(6) Colour the eyes black with
white highlights. Finally,
add rosy cheeks with
highlights to complete the
smiling kawaii face!

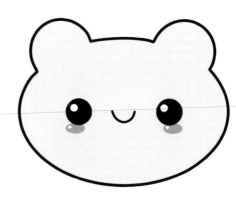

Shy

Gently blushed cheeks make this shy face – choose between
black and sparkly or too-shy-to-open closed eyes.

1. Draw an oval for the face
 and two circles for ears.
 Add a cross in the middle.

2. Add two eyes spaced evenly
 on the horizontal line, with
 smaller circles for highlights.
 Draw the highlights in the
 same position in both eyes.

3. Add a U-shape on
 the vertical line for the
 mouth. Add short, angled
 lines under the eyes to
 show blushed cheeks.

4. Ink the outline with
 a thick, smooth line.
 Use a thinner line to
 ink the features.

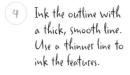

5. Add a flat, even colour to the face.
 Colour the eyes. Add a rosy colour
 over the lines on the cheek to
 complete your shy face!

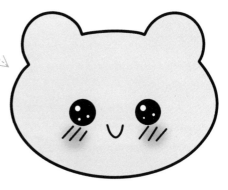

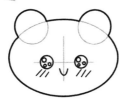

Variation
For a different shy face,
try closing the eyes using
simple lines, and add
a coloured triangle
for the mouth.

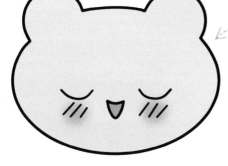

Crying

Choose between sparkly blue or tightly shut eyes in this sad,
crying face, both with a simple but essential tear drop.

1. Draw an oval for the face and two circles for ears. Add a cross in the middle.

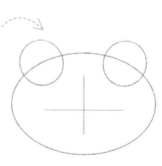

2. Space the eyes evenly on the horizontal line. Add a teardrop under one of the eyes, slightly overlapping. Add an arch on the vertical line for the mouth.

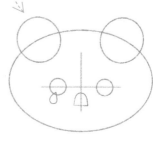

3. Add two curvy lines for eyebrows. Then add two highlights inside both eyes, with one of the highlights bigger than the one below.

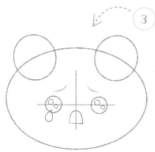

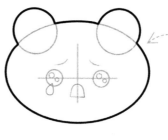

4. Ink the outline with a thick and even, smooth line.

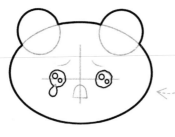

5. Use a thinner, uneven line to ink the eyes. Make sure the eye and the teardrop are connected, as they are here.

12

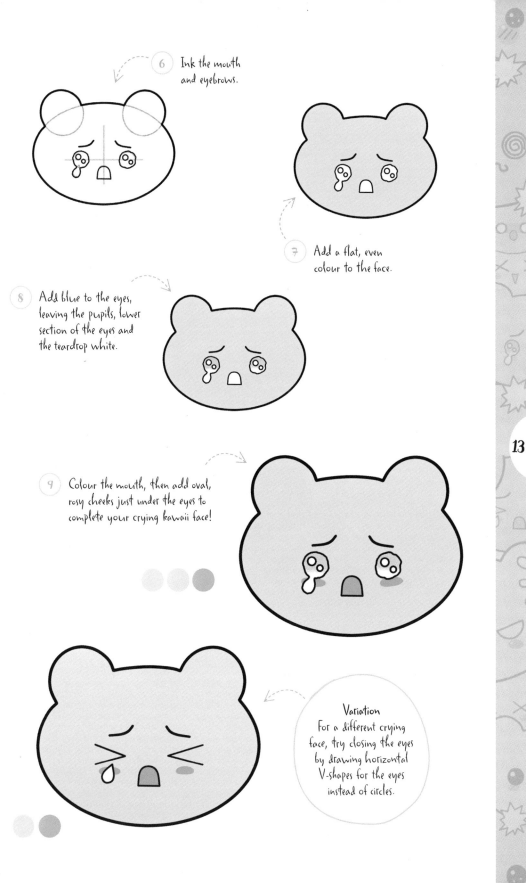

6 Ink the mouth and eyebrows.

7 Add a flat, even colour to the face.

8 Add blue to the eyes, leaving the pupils, lower section of the eyes and the teardrop white.

9 Colour the mouth, then add oval, rosy cheeks just under the eyes to complete your crying kawaii face!

Variation
For a different crying face, try closing the eyes by drawing horizontal V-shapes for the eyes instead of circles.

13

Shocked

A shocked expression is easy to achieve with an open mouth,
pale skin and a spiky flash for effect!

1 Draw an oval for the face and two small circles for ears. Add a cross in the middle.

2 Space the eyes evenly on the horizontal line. Add an oval on the vertical line for the mouth.

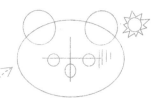

3 Sketch a few vertical lines to show shadow on the face. Add a spiky flash next to one ear.

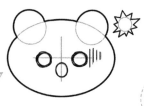

4 Ink the outlines. Use a slightly uneven line for the eyes, and trace around them several times.

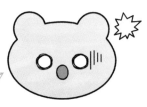

5 Add a flat, even colour to the face. Colour the mouth red. Leave the eyes white.

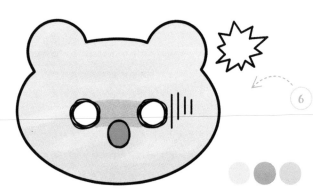

6 Add a darker-blue shade between the eyes to show a face pale from shock.

Cute

Pink, rosy cheeks and a wiggly mouth create this expression –
try winking one eye for the ultimate in cute!

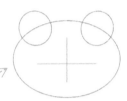

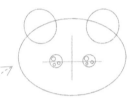

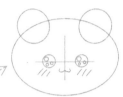

1 Draw an oval for the
 face and two small circles
 for ears. Add a cross in
 the middle.

2 Add two eyes spaced evenly
 on the horizontal line, with
 smaller circles for highlights.
 Draw the highlights in the
 same position in both eyes.

3 Add a w-shaped mouth
 on the vertical line.
 Draw short, angled
 lines under the eyes to
 show blushed cheeks.

4 Ink the outline with a
 smooth, thick and even line.
 Use a slightly thinner line
 to ink the features.

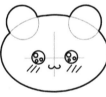

5 Add a flat, even colour to the face.
 Colour the eyes, and add round, rosy
 cheeks. Add little highlights on the
 cheeks to complete the cute face!

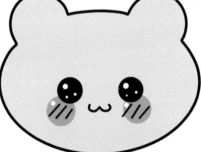

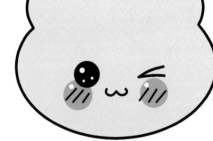

Variation
Why don't you make
your cute face wink?
Replace one of the eyes
with a slightly curved,
horizontal V-shape.

Angry

Even angry expressions look cute in the kawaii style! Furrowed eyebrows
and an angry symbol to the side are the ingredients to this angry face.

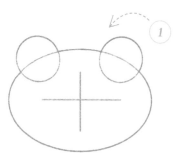

1. Draw an oval for the face and two small circles for ears. Add a cross in the middle.

2. Add two slightly angled semi-circles just below the horizontal line for the eyes.

3. Draw a wide U-shape for the eyebrows. Add two slightly angled, short, vertical lines in the middle of the cross to indicate wrinkles between the eyebrows.

4. Add a dome across the vertical line for an open, complaining, kawaii mouth.

5. Add the angry symbol — a manga iconograph. First draw an angled cross on the side of the forehead, then add four curvy lines in each corner of the cross.

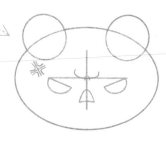

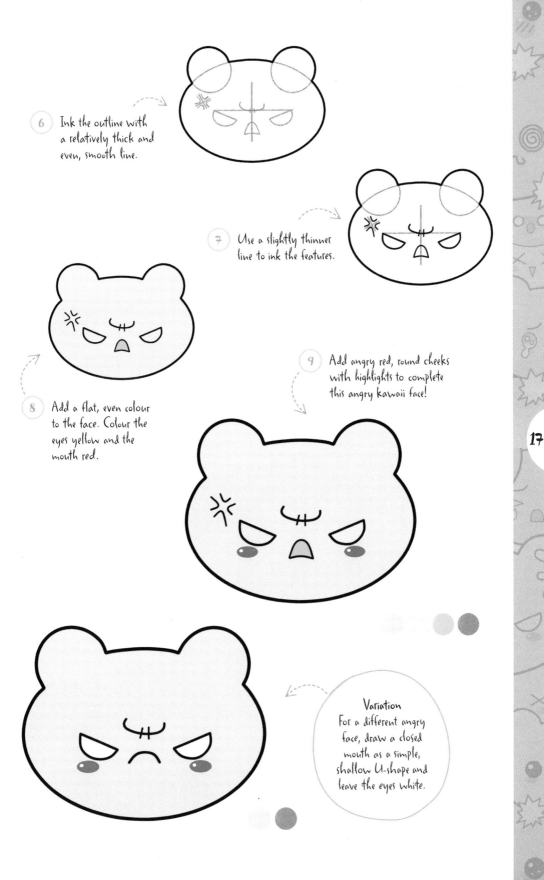

6 Ink the outline with a relatively thick and even, smooth line.

7 Use a slightly thinner line to ink the features.

8 Add a flat, even colour to the face. Colour the eyes yellow and the mouth red.

9 Add angry red, round cheeks with highlights to complete this angry kawaii face!

Variation
For a different angry face, draw a closed mouth as a simple, shallow U-shape and leave the eyes white.

17

Panicked

Tightly closed eyes, a thin mouth and sweat drops to the side
are the simple ingredients to this panicked face.

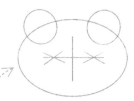

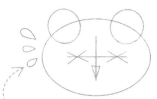

1. Draw an oval for the face and two small circles for ears. Add a cross in the middle.

2. Add two crosses on the horizontal line for the eyes.

3. Add a thin triangle on the vertical line for the mouth, and some sweat drops beside the face. Change the size of each drop slightly.

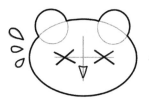

4. Ink the outline with a thick and even, smooth line. Ink the eyes. Use a slightly thinner line to ink the features and sweat drops.

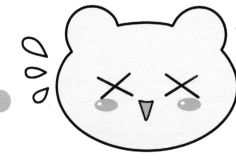

5. Add a flat, even colour to the face. Colour the mouth, and finish with oval, rosy cheeks with highlights.

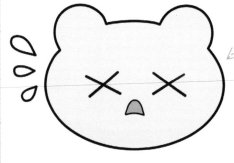

Variation
Try changing the thin, triangular mouth to a rounder version, and omitting the rosy cheeks.

Confused

Yellow spiral eyes, a dramatic, wiggly mouth with question marks
around the outside all make up this confused face.

 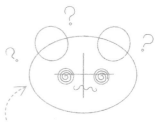

1. Draw an oval for the face and two small circles for ears. Add a cross in the middle.

2. Sketch two circles hanging from the horizontal line. Then add slightly uneven spirals inside each eye.

3. Draw a wiggly line for the mouth, and question marks around the head.

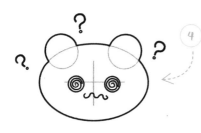

4. Ink the outline with a thick and even, smooth line. Use a slightly thinner line to ink the features. Ink the spirals with uneven lines to create an uncertain feel.

5. Add a flat, even colour to the face. Finish by colouring the eyes yellow.

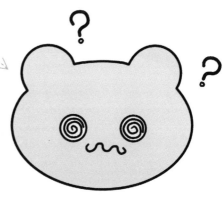

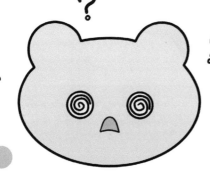

Variation
For a different confused
face, try a dome-shaped
mouth instead of
a wiggly line.

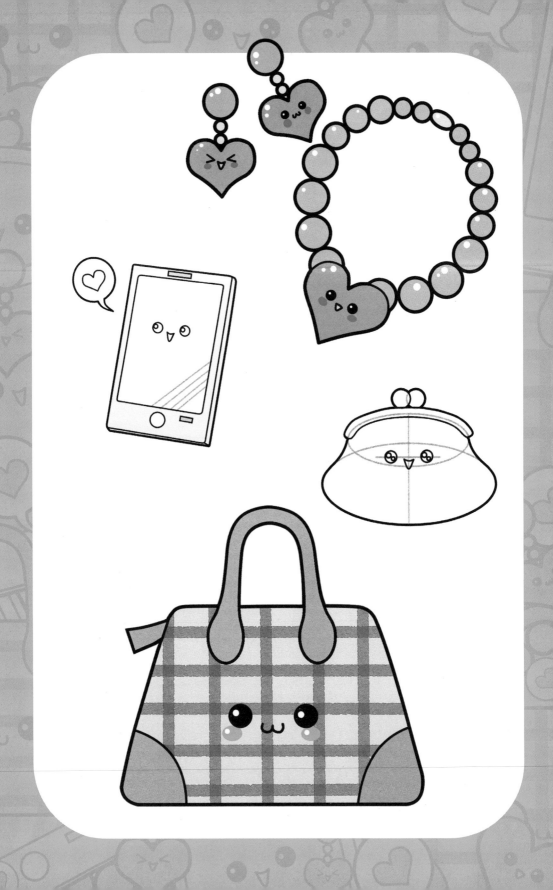

Kawaii Accessories

Phone

Experiment with words or symbols inside the speech
bubble of this kawaii mobile phone.

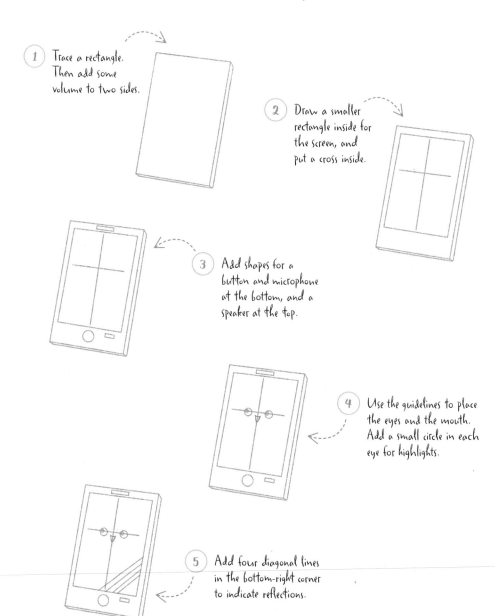

1. Trace a rectangle.
Then add some
volume to two sides.

2. Draw a smaller
rectangle inside for
the screen, and
put a cross inside.

22

3. Add shapes for a
button and microphone
at the bottom, and a
speaker at the top.

4. Use the guidelines to place
the eyes and the mouth.
Add a small circle in each
eye for highlights.

5. Add four diagonal lines
in the bottom-right corner
to indicate reflections.

6 Add a speech bubble using a circle and a curved tail. Draw a heart or a word inside.

7 Start inking using smooth, even lines. Then thicken the outline evenly. Leave the diagonal lines added in step 5.

8 Start to add colour in flat, even shades. Colour the outer shell first.

9 Colour the eyes and mouth. Choose a colour to paint the screen. Leave white between the diagonal reflection lines.

10 Colour the heart inside the speech bubble and add rosy cheeks to the face. Finish by adding white highlights to the cheeks.

Purse

Symmetry and proportion are key to this pretty purse –
stripey or spotty, you choose!

(1) Draw a vertical line.

(2) Add two overlapping ovals
centred across the line. The
top oval should be smaller
than the bottom one.

(3) Connect the sides of
the ovals with smooth,
curved lines.

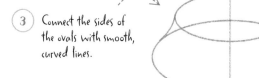

(4) Add a short horizontal line
to help position the face.
Add the eyes and a mouth.
Add highlights to the eyes.

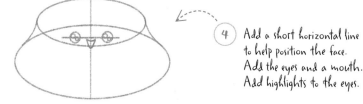

(5) Add a curved tube
shape over the top.

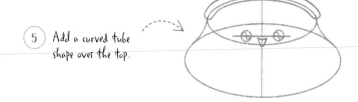

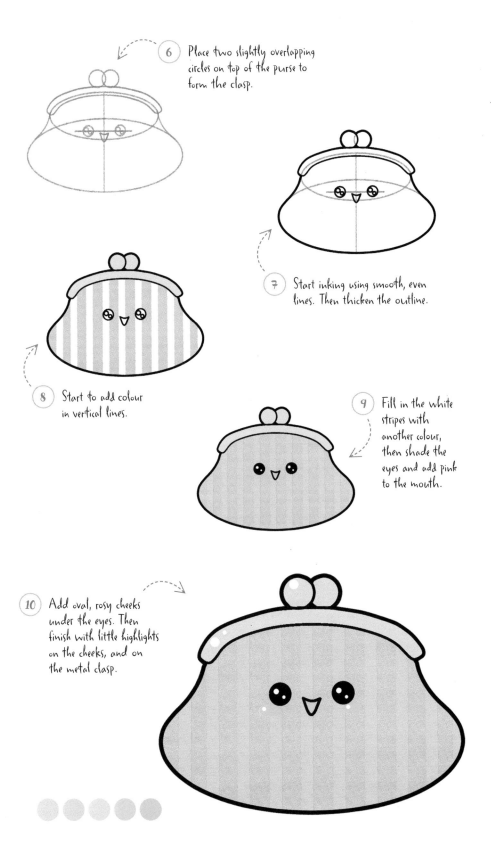

6 Place two slightly overlapping circles on top of the purse to form the clasp.

7 Start inking using smooth, even lines. Then thicken the outline.

8 Start to add colour in vertical lines.

9 Fill in the white stripes with another colour, then shade the eyes and add pink to the mouth.

10 Add oval, rosy cheeks under the eyes. Then finish with little highlights on the cheeks, and on the metal clasp.

Handbag

Straight lines contrast with curves and ovals in this simple, stylish handbag.
Follow the checked pattern, or go freestyle and choose your own.

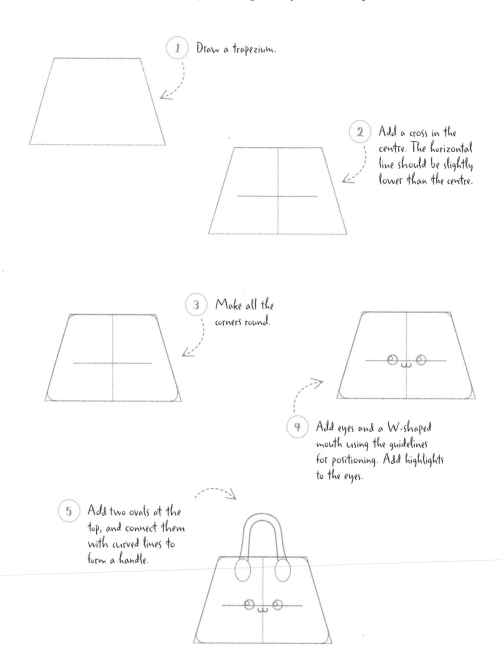

1　Draw a trapezium.

2　Add a cross in the centre. The horizontal line should be slightly lower than the centre.

3　Make all the corners round.

4　Add eyes and a W-shaped mouth using the guidelines for positioning. Add highlights to the eyes.

5　Add two ovals at the top, and connect them with curved lines to form a handle.

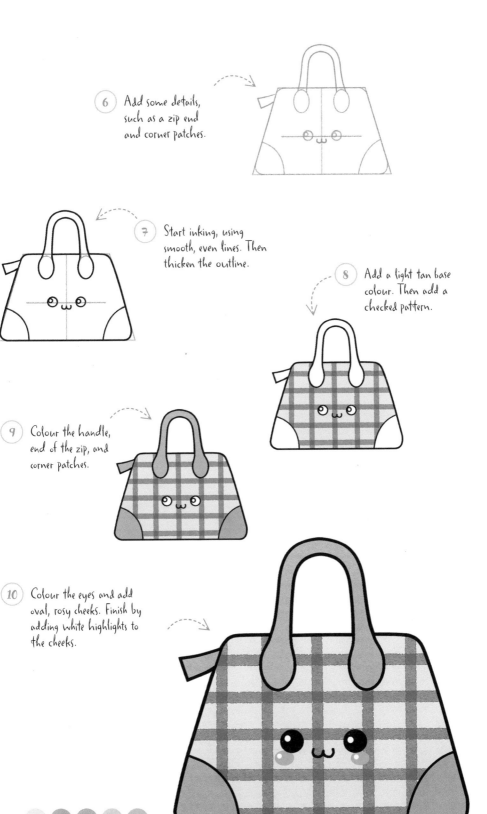

6 Add some details, such as a zip end and corner patches.

7 Start inking, using smooth, even lines. Then thicken the outline.

8 Add a light tan base colour. Then add a checked pattern.

9 Colour the handle, end of the zip, and corner patches.

10 Colour the eyes and add oval, rosy cheeks. Finish by adding white highlights to the cheeks.

Jewellery

Create this matching set of bracelet and earrings using circles
of every size, and a single oval for the clasp.

1 Draw a large circle, with a diagonal line through the centre for the bracelet. Draw two smaller circles with short lines below, for the earrings.

2 Draw two smaller circles on each of the earrings.

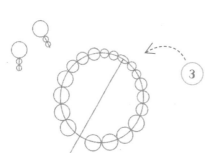

3 On the large circle, add small circles all the way round for the beads. At the top of the diagonal line, add an oval instead of a circle. This will be the clasp.

4 Add heart-shaped charms to the earrings and bracelet.

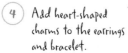

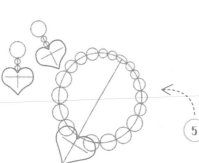

5 Draw crosses inside each heart.

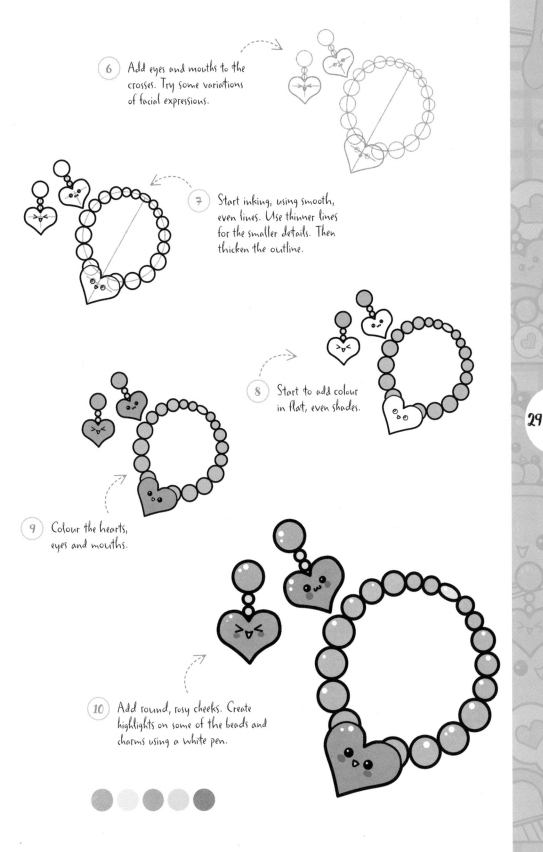

6) Add eyes and mouths to the crosses. Try some variations of facial expressions.

7) Start inking, using smooth, even lines. Use thinner lines for the smaller details. Then thicken the outline.

8) Start to add colour in flat, even shades.

9) Colour the hearts, eyes and mouths.

10) Add round, rosy cheeks. Create highlights on some of the beads and charms using a white pen.

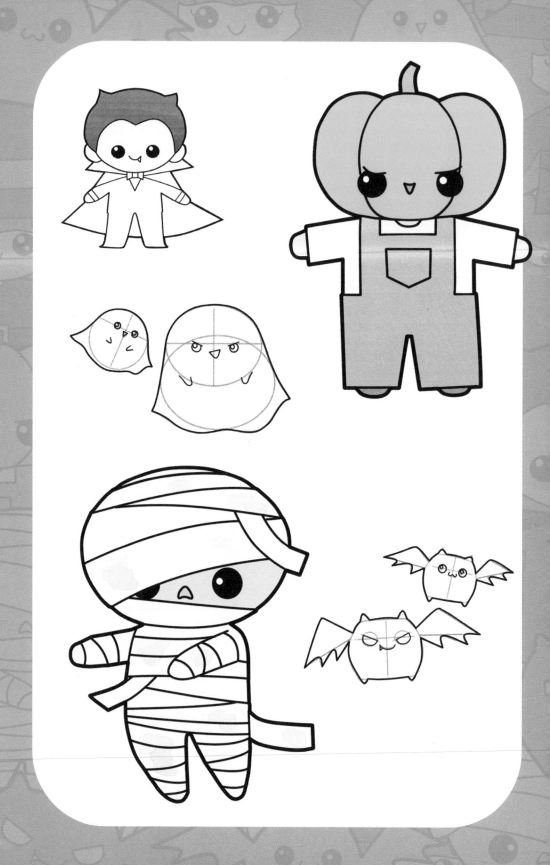

Kawaii Monsters

Ghosts

Create some double trouble with these ghosts. Use darker
colours to make them more scary.

1. Draw two ovals, slightly
 overlapping each other. Next
 to them, draw a single circle.

2. Connect the two ovals on the right,
 and add a wavy hem. Add a wavy
 hem to the circle on the left, too.

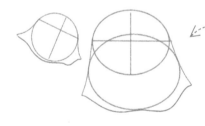

3. Add a cross to the top
 oval and the circle.

4. Add two pairs of eyes on the
 guidelines. For the ghost on the
 right, add short, angled lines to
 the tops of the eyes to make it
 slightly angry.

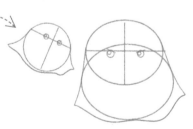

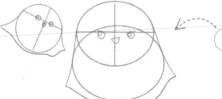

5. Add the mouths. Draw the
 mouth on the right at an
 angle for an angry look.

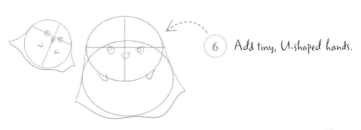

6 Add tiny, U-shaped hands.

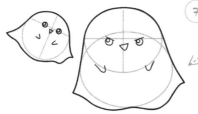

7 Ink the outlines using smooth, even lines. Then thicken the outline evenly.

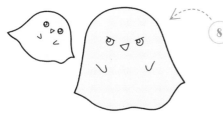

8 Start to add colour in flat, even shades. Pick slightly dark pastel colours to make the ghosts cute but scary.

9 Colour the eyes and mouths. Add shadow between the eyes of the right ghost to make it more scary.

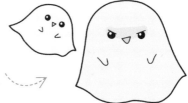

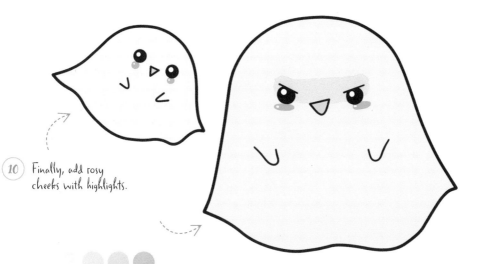

10 Finally, add rosy cheeks with highlights.

Mummy

Work your way from head to toe, carefully positioning the
bandages of this not-so-scary mummy.

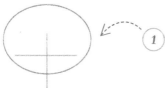

1 Draw an oval, then
add an elongated cross
in its lower half.

2 Sketch a round-topped
square for the body. Draw
cone shapes for the legs and
some sausage shapes for the
arms. Point both arms in
the same direction.

3 Add the eyes and mouth on
the guidelines. Include a
highlight in the right eye.

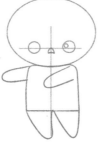

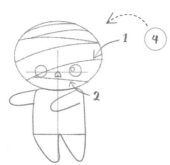

1

2

4 Add the first bandage with a curved line (1),
which covers half of the left eye. Then draw a
second line (2). This will be the part of the
face not covered by the bandages. For the rest
of the head, draw curved lines roughly parallel
to each other.

5 Add more bandages to
the arms and legs.

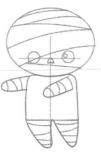

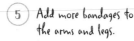

6 Add more bandages to the body.

7 Add three bandage ends as curved, rectangular shapes. Make sure that one end of each comes from under the strips on the body.

8 Start inking, using smooth, even lines. Then thicken the outline.

9 Colour the face a pale, mossy green, leaving the eyes and mouth white. Use a very pale grey for the bandaged part.

10 Colour the eyes and mouth, then finish by adding some dirt to the bandages.

Pumpkin head

The eyes of this pumpkin-headed character may look a little angry,
but the dungarees just make him look cute!

(1) Draw a square-ish
oval. Add a cross
that is centred slightly
lower in the oval.

(2) Add a round-topped
square for the body.

(3) Create the arms and
legs by positioning
short sausage shapes
extending out from
the body.

(4) Add half-moon
shapes to both
sides of the head.

(5) Add the eyes and mouth on the
guidelines. Create down-curved
eyebrows on top of the eyes for
an intense look. Add a tiny
curved rectangle on top of the
head for the stem.

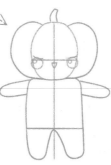

6 Draw some dungarees. First draw the trousers (1). Add the outline of a T-shirt with long sleeves (2). Then add a tiny U-shape under the chin for the T-shirt's neckline (3).

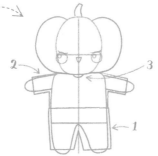

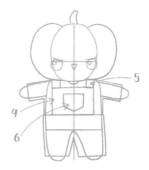

7 Now add the chest (4) and shoulder straps (5). Finally, add a pentagon-shaped pocket (6).

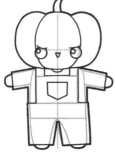

8 Start inking, using smooth, even lines. Then thicken the outline.

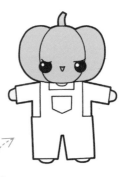

9 Add a flat, even orange colour to the head. Use green for the stem and pink for the mouth. Add pale peach for the hands and neck.

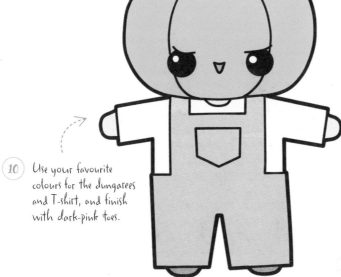

10 Use your favourite colours for the dungarees and T-shirt, and finish with dark-pink toes.

Bat

Triangles are the main shape used to draw these bats.
Add a fang and yellow eyes for a scary version!!

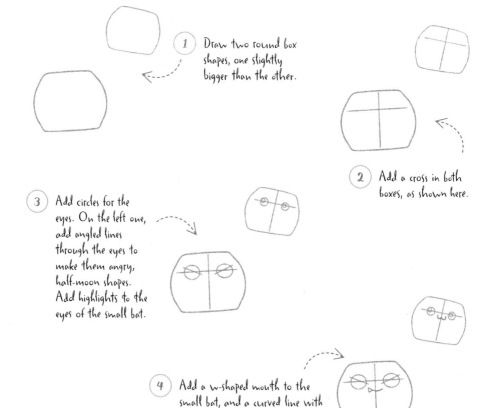

1 Draw two round box
shapes, one slightly
bigger than the other.

2 Add a cross in both
boxes, as shown here.

3 Add circles for the
eyes. On the left one,
add angled lines
through the eyes to
make them angry,
half-moon shapes.
Add highlights to the
eyes of the small bat.

4 Add a w-shaped mouth to the
small bat, and a curved line with
a triangle to create the fanged
mouth of the larger bat.

5 Add two triangular
shapes to the sides of
each body for the wings.

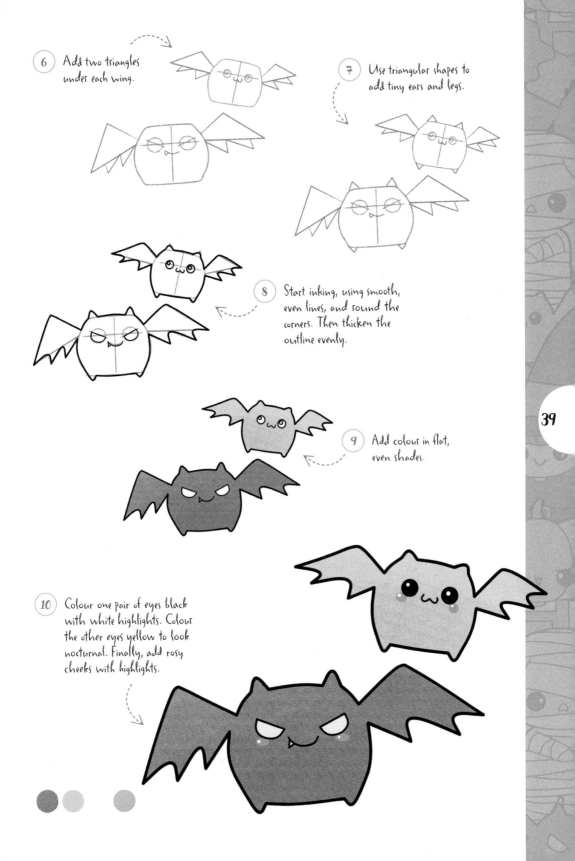

6 Add two triangles under each wing.

7 Use triangular shapes to add tiny ears and legs.

8 Start inking, using smooth, even lines, and round the corners. Then thicken the outline evenly.

9 Add colour in flat, even shades.

10 Colour one pair of eyes black with white highlights. Colour the other eyes yellow to look nocturnal. Finally, add rosy cheeks with highlights.

Vampire

Purple works well with a vampire theme, but the cape of this creepy
character would look great in any rich colour if you prefer.

1. Draw an oval, then add a cross in its lower half.

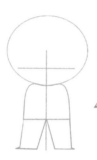

2. Add a dome shape for the body. Then add two rectangular shapes for the legs. Make the outside corners pointy to indicate tiny feet.

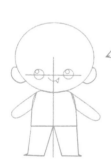

3. Draw sausage shapes for the arms. Then add eyes and a mouth using the guidelines for positioning. Add a fang by drawing a tiny triangle on the edge of the mouth.

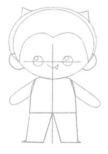

4. Add a centre-parted helmet shape on the head as shown here. Make sure the hairline is curvy, not straight. Add two tiny triangles on top for horns.

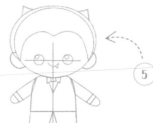

5. Draw a bow tie and a V-shape under the chin. Add two lines to the arms to indicate shirt cuffs showing under the jacket.

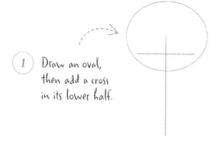

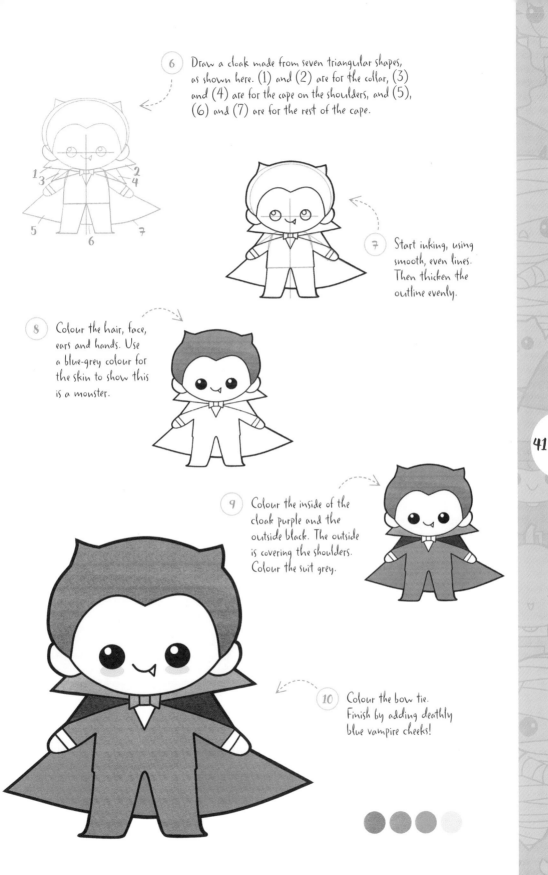

6 Draw a cloak made from seven triangular shapes, as shown here. (1) and (2) are for the collar, (3) and (4) are for the cape on the shoulders, and (5), (6) and (7) are for the rest of the cape.

1
3
2
4
5
6
7

7 Start inking, using smooth, even lines. Then thicken the outline evenly.

8 Colour the hair, face, ears and hands. Use a blue-grey colour for the skin to show this is a monster.

9 Colour the inside of the cloak purple and the outside black. The outside is covering the shoulders. Colour the suit grey.

10 Colour the bow tie. Finish by adding deathly blue vampire cheeks!

Witch

Keep the shapes simple as you draw this kawaii witch,
complete with a textured broomstick.

1 Draw an oval,
then add a cross
in its lower half.

2 Add a dome shape below,
with one side curved
outwards as shown here to
form the hem of the dress.

3 Add triangular shapes
for the arms, with tiny
semi-circles at the ends for
the hands. Add U-shapes
below for the legs. Then
add the eyes and mouth,
using the guidelines
for positioning.

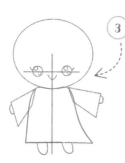

4 Trace a helmet shape on the
head as shown here. Add a
few curved hair lines to
indicate a fringe. Now add
an upside-down fan shape
behind to become the area
of long hair.

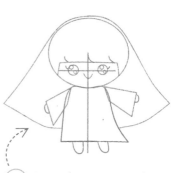

5 Draw a witch's hat by
sketching a trapezium
(1), followed by two
triangles (2) and (3).

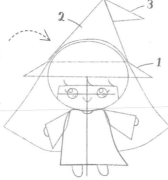

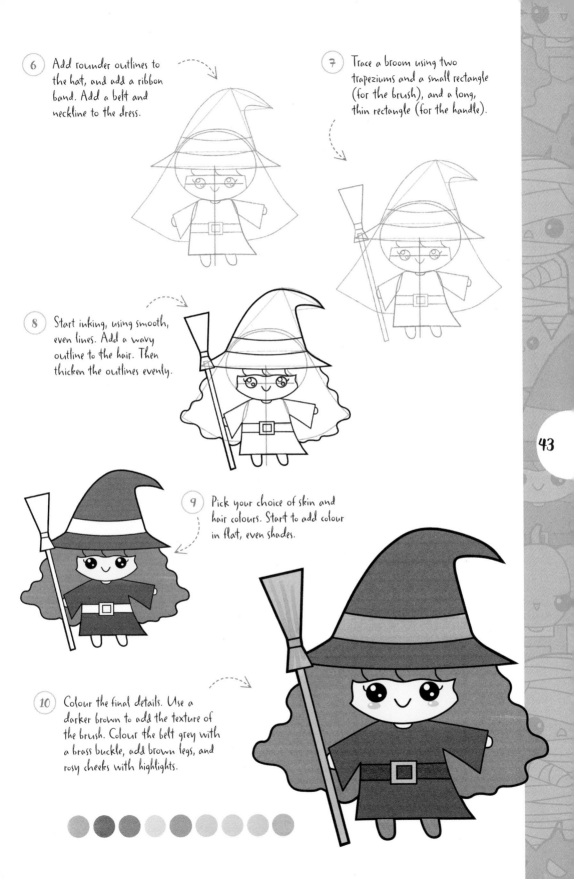

6. Add rounder outlines to the hat, and add a ribbon band. Add a belt and neckline to the dress.

7. Trace a broom using two trapeziums and a small rectangle (for the brush), and a long, thin rectangle (for the handle).

8. Start inking, using smooth, even lines. Add a wavy outline to the hair. Then thicken the outlines evenly.

9. Pick your choice of skin and hair colours. Start to add colour in flat, even shades.

10. Colour the final details. Use a darker brown to add the texture of the brush. Colour the belt grey with a brass buckle, add brown legs, and rosy cheeks with highlights.

43

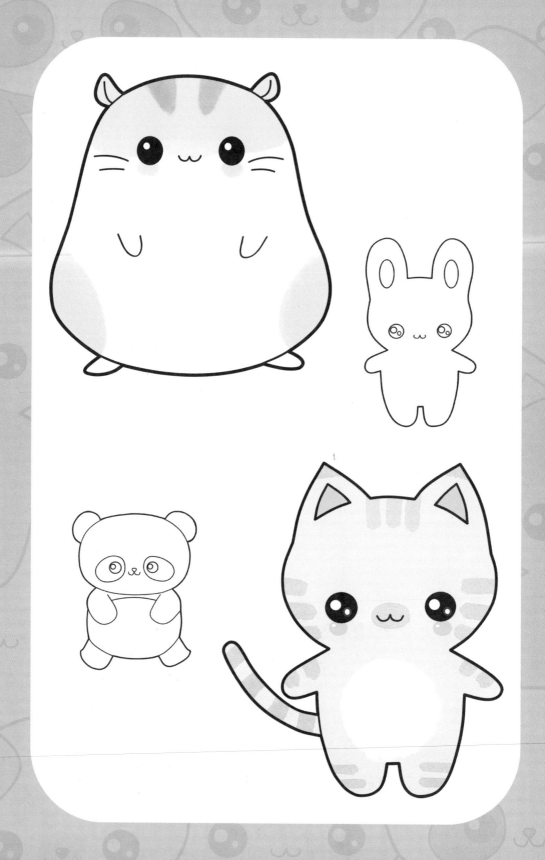

Kawaii Animals

Panda

Practise your ovals with this cute panda, drawn from layers of soft, fat, oval shapes.

(1) Draw two overlapping, circular shapes for the head and body.

(2) Draw a cross in the top shape, centred in the lower half.

(3) Add two small, rounded rectangles for the front legs, and join them with a curved line. Then add two rounder shapes below for the legs. Shape the lower outer edges of the legs to form little toes.

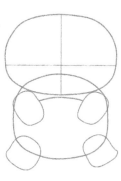

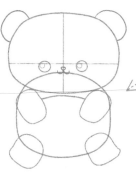

(4) Draw two semi-circles on top of the head for the ears.

(5) Make the eyes cute and round, with circular highlights. Add a little triangle for the nose, and a tiny w-shaped mouth.

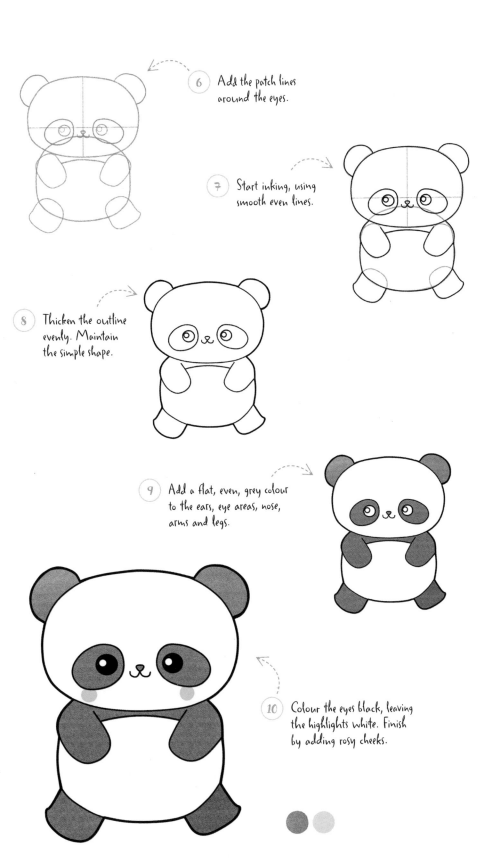

6 Add the patch lines around the eyes.

7 Start inking, using smooth even lines.

8 Thicken the outline evenly. Maintain the simple shape.

9 Add a flat, even, grey colour to the ears, eye areas, nose, arms and legs.

10 Colour the eyes black, leaving the highlights white. Finish by adding rosy cheeks.

Rabbit

Pick any soft, pastel colour to emphasise the
cuteness of this bunny rabbit.

1 Draw an oval, then add an
overlapping rounded square below.

2 Draw a cross in the oval, with
the horizontal line slightly
lower than the centre.

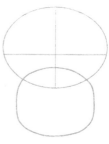

3 Add short, round
arms to the sides,
and legs beneath.

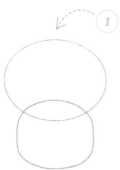

4 Draw two tall ovals on top
of the head, with smaller
ovals inside.

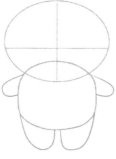

5 Connect the ears
to the head with
curved lines, as
the arrows show.

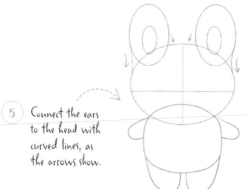
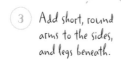

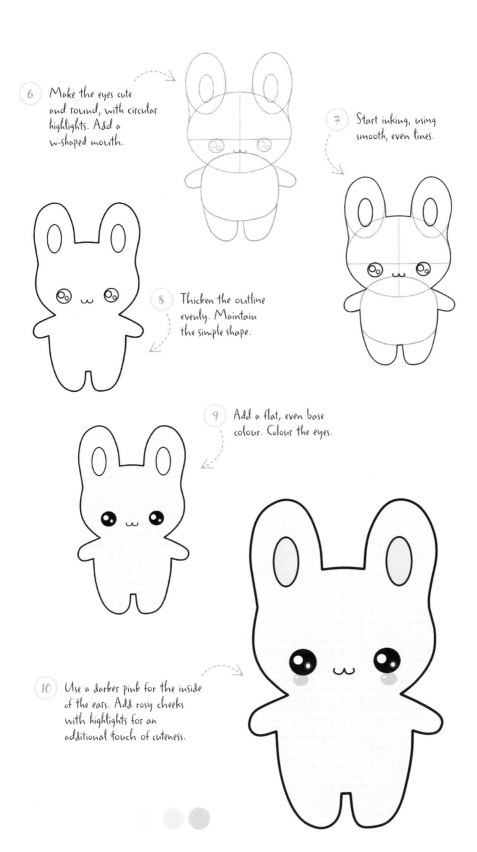

6 Make the eyes cute and round, with circular highlights. Add a w-shaped mouth.

7 Start inking, using smooth, even lines.

8 Thicken the outline evenly. Maintain the simple shape.

9 Add a flat, even base colour. Colour the eyes.

10 Use a darker pink for the inside of the ears. Add rosy cheeks with highlights for an additional touch of cuteness.

Dog

Keep all your shapes fat and round for this happy
dog with a wagging tail.

1. Draw an oval, then
add a rounded square
below. The two shapes
should overlap.

2. Draw a cross in the oval, with
the horizontal line slightly
lower than the centre.

3. Add short, round legs to
the sides, and rounded
legs below.

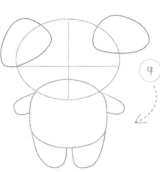

4. Draw two very round
triangles on top of the
head, with one of them
slightly tilted.

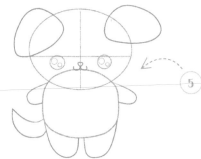

5. Make the eyes cute and round, with
circular highlights. Add a w-shaped
mouth and a crescent-shaped tail.

6 Start inking, using smooth, even lines.

7 Thicken the outline evenly.

8 Add a flat, even base colour. Colour the eyes.

9 Add a soft brown to the ears, around the nose, and tips of the legs and tail.

10 Use a pink shade to create the dog's rosy cheeks, and add highlights with a white pen.

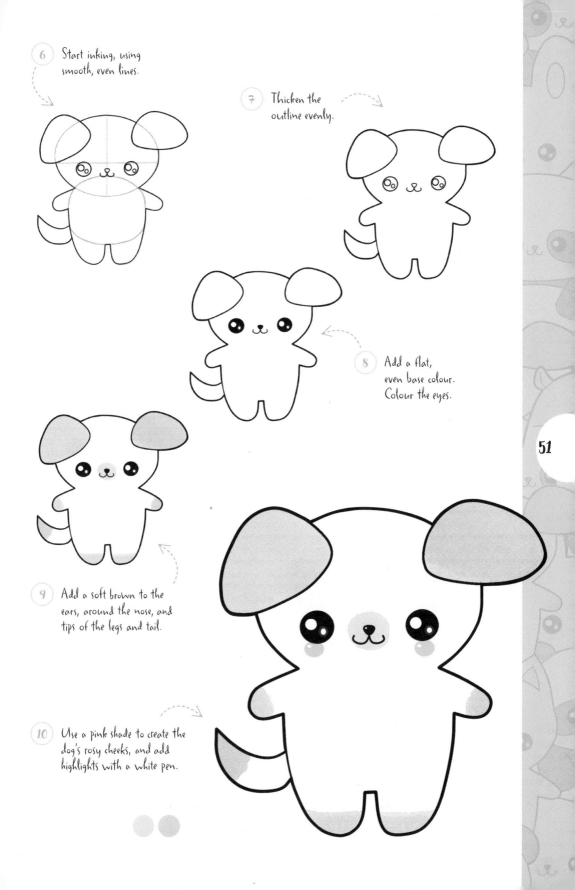

Cat

This sparkly eyed tabby cat is all curves and triangles.
Even the tummy patch is round!

1. Draw an oval, then add an overlapping, rounded square shape below.

2. Draw a cross in the oval, with the horizontal line slightly lower than the centre.

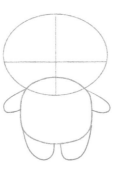

3. Add short, round legs to the sides, and rounded legs below.

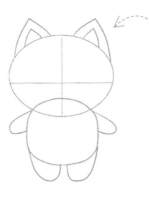

4. Draw two wide triangles on top of the head, with smaller triangles inside.

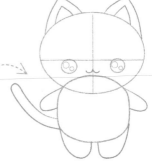

5. Make the eyes cute and round, with circular highlights. Draw a w-shaped mouth. Add a tail.

52

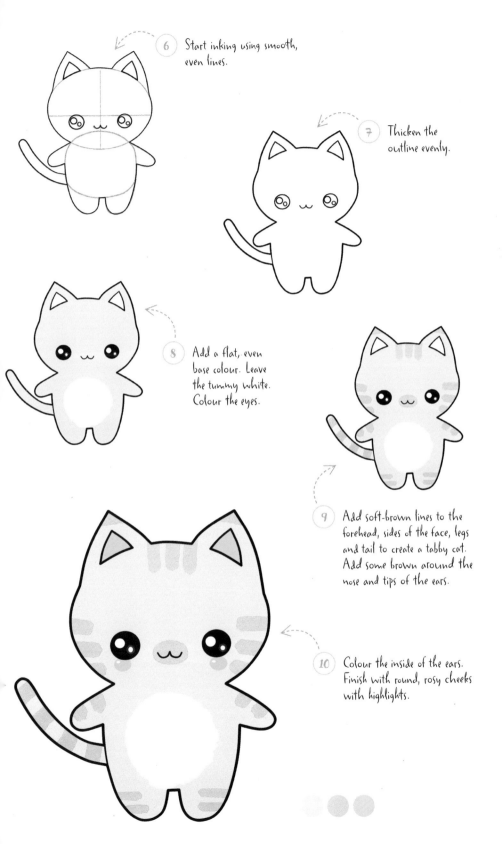

6 Start inking using smooth, even lines.

7 Thicken the outline evenly.

8 Add a flat, even base colour. Leave the tummy white. Colour the eyes.

9 Add soft-brown lines to the forehead, sides of the face, legs and tail to create a tabby cat. Add some brown around the nose and tips of the ears.

10 Colour the inside of the ears. Finish with round, rosy cheeks with highlights.

Hamster

Everything about this hamster is understated, from its tiny
ears to the merest hint of front feet!

1. Draw two fat,
 overlapping ovals.

2. Divide the top oval into four sections.
 Then divide the top two sections
 into two to mark the positions of
 the eyes, mouth and ears.

3. Connect the shapes to
 form a round and
 chubby hamster body.

4. Make the eyes cute and round, with
 circular highlights. Draw a w-shaped
 mouth. Add tiny ears, hands and feet.
 Don't forget the whiskers!

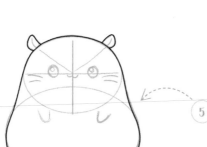

5. Start inking using
 smooth, even lines.

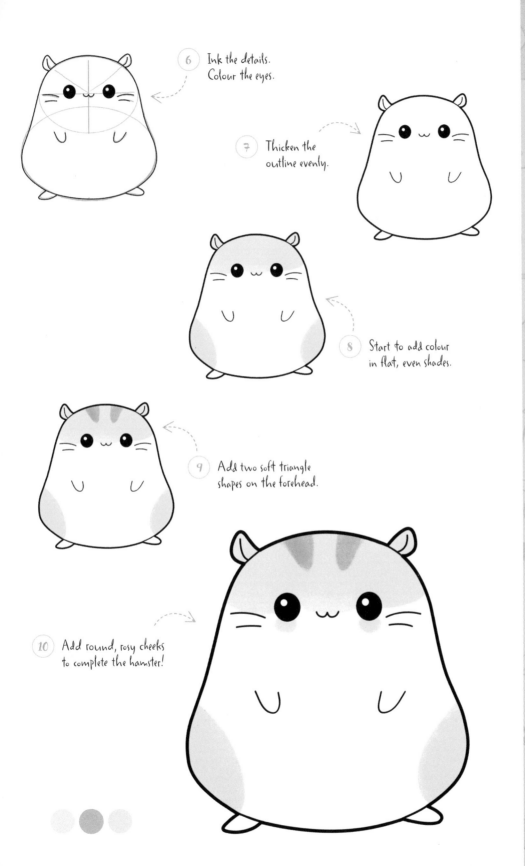

6　Ink the details.
Colour the eyes.

7　Thicken the
outline evenly.

8　Start to add colour
in flat, even shades.

9　Add two soft triangle
shapes on the forehead.

10　Add round, rosy cheeks
to complete the hamster!

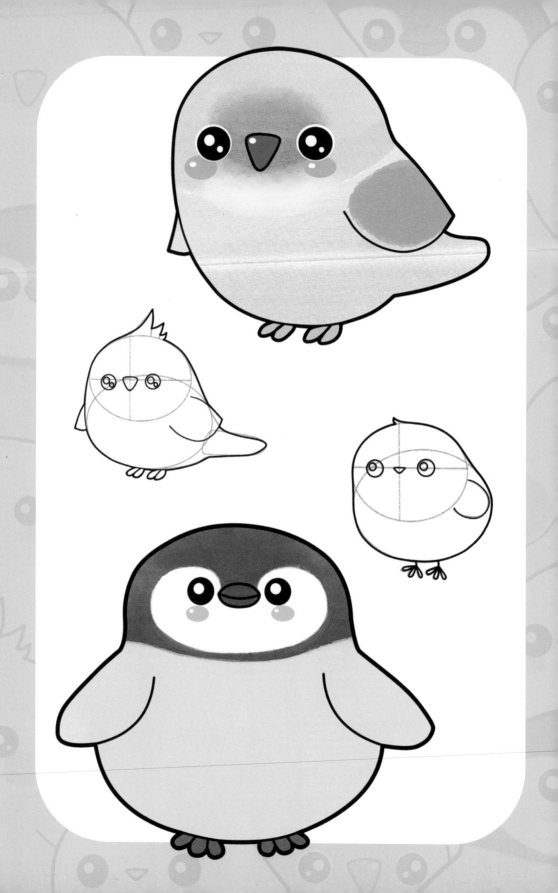

Kawaii Birds

Cockatiel

Pay special attention to the distinctive crest feathers
on this favourite, plump parakeet.

1. Draw two
overlapping ovals.

2. Draw a cross inside the
top oval, centred slightly
to the left.

3. Add a cone shape to the bottom
right for the tail feathers.
Connect the shapes to form a
round and chubby cockatiel.

4. Add big, round eyes with
highlights. Add a cute,
triangular beak.

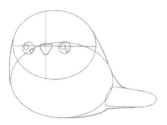

5. Add the wings. The left wing is
mostly behind the body. Then
add three tiny triangles on top of
the head for the head feathers.

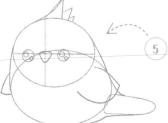

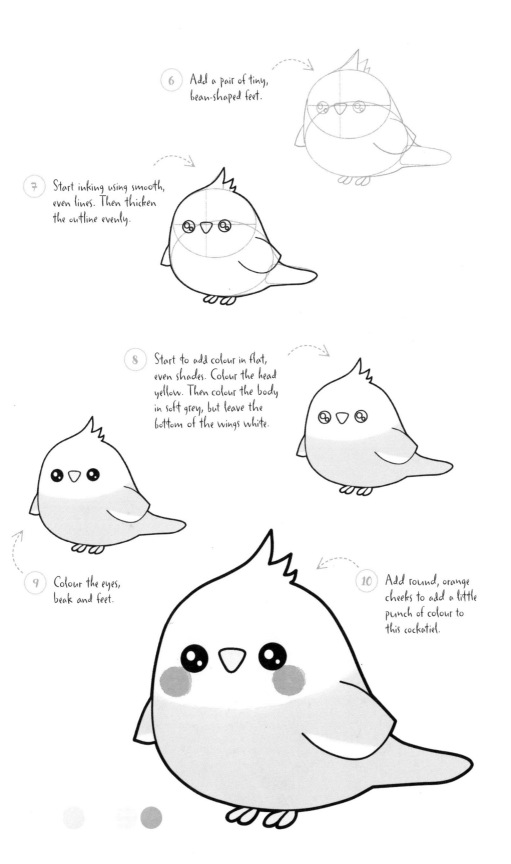

6. Add a pair of tiny, bean-shaped feet.

7. Start inking using smooth, even lines. Then thicken the outline evenly.

8. Start to add colour in flat, even shades. Colour the head yellow. Then colour the body in soft grey, but leave the bottom of the wings white.

9. Colour the eyes, beak and feet.

10. Add round, orange cheeks to add a little punch of colour to this cockatiel.

Penguin

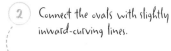

This fluffy penguin is the perfect addition
to your winter kawaii scene.

1. Draw two
overlapping ovals.

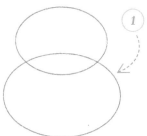

2. Connect the ovals with slightly
inward-curving lines.

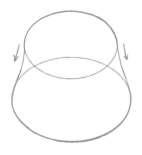

3. Draw a smaller oval inside the
top one. Add a cross inside the top
oval, with the horizontal line
slightly higher than the centre.

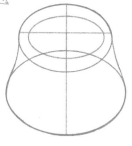

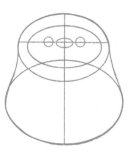

4. Add a squashed oval in the centre
of the cross for the beak, and
a circle either side for the eyes.

5. Add the wings, and bean-like shapes for
the tiny feet. Add the top of the face with
curved lines from the beak. Add highlights
to both eyes, and draw a smile on the beak.

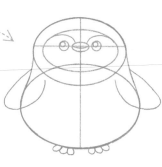

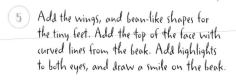

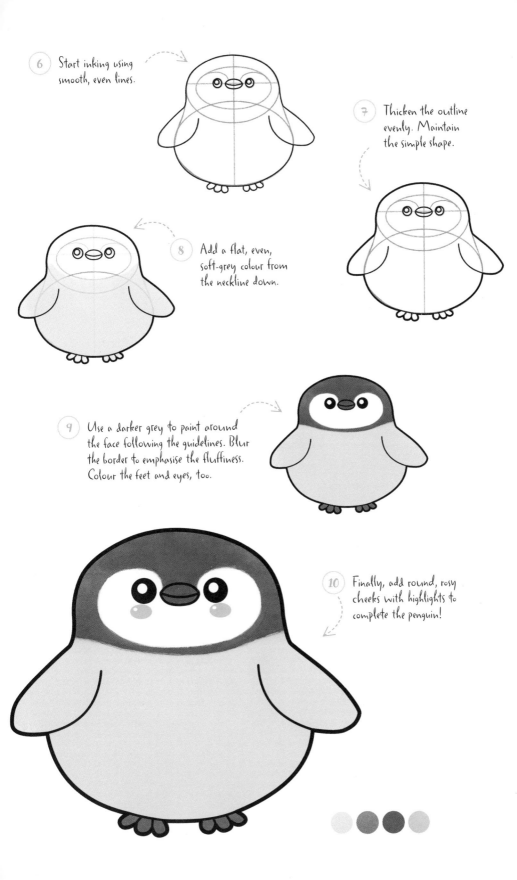

6 Start inking using smooth, even lines.

7 Thicken the outline evenly. Maintain the simple shape.

8 Add a flat, even, soft-grey colour from the neckline down.

9 Use a darker grey to paint around the face following the guidelines. Blur the border to emphasise the fluffiness. Colour the feet and eyes, too.

10 Finally, add round, rosy cheeks with highlights to complete the penguin!

Chick

A single, tiny feather on top of its head is all it
takes to identify this plump baby bird.

1 Draw two overlapping ovals.

2 Draw a cross inside the top
oval, with the vertical line
slightly left of the centre.

62

3 Connect the shapes
to form a round,
chubby chick.

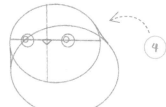

4 Add round eyes with one circular highlight
in each, and a cute triangular beak.

5 Add a single
round wing.

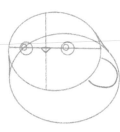

6 Add a tiny feather on top of the head.

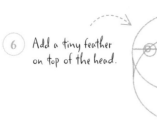

7 Draw the feet with narrow, bean-shaped toes on very short legs.

8 Start inking using smooth, even lines. Then thicken the outline evenly. Maintain the simple shape.

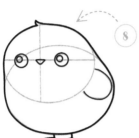

9 Add a flat, even colour. Colour the eyes.

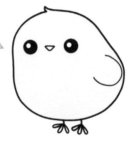

10 Colour the beak and feet. Finally, add round, rosy cheeks with highlights.

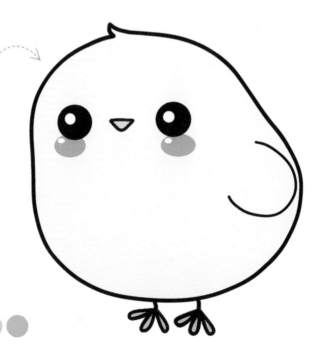

Lovebird

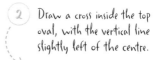

Lovebirds are famous for their colourful feathers as well as their strong bonds, and this one's no exception!

1. Draw two overlapping ovals.

2. Draw a cross inside the top oval, with the vertical line slightly left of the centre.

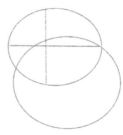

3. Add a cone shape to the bottom right for the tail feathers. Then connect the shapes with curvy lines.

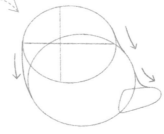

4. Add big, round eyes with highlights, and a fat, triangular beak.

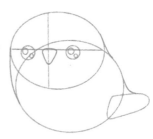

5. Add the wings. The left wing is mostly behind the body.

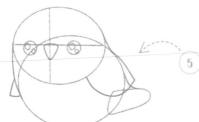

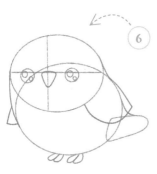

6 Add a pair of tiny, bean-shaped feet.

7 Start inking using smooth, even lines. Then thicken the outline evenly. Maintain the simple shape.

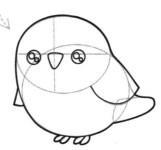

8 Start to add flat, even colours. Colour the head orange, but leave the outline of the eyes white. Colour the body soft green and the right wing a darker green. Colour the eyes, leaving the highlights white.

9 Add darker orange around the beak, and yellow under the beak.

10 Colour the beak with a reddish orange and the feet in grey. Finally, add round, rosy cheeks with highlights to complete the kawaii lovebird!

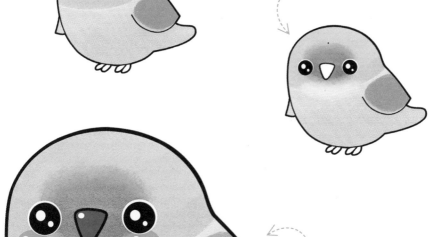

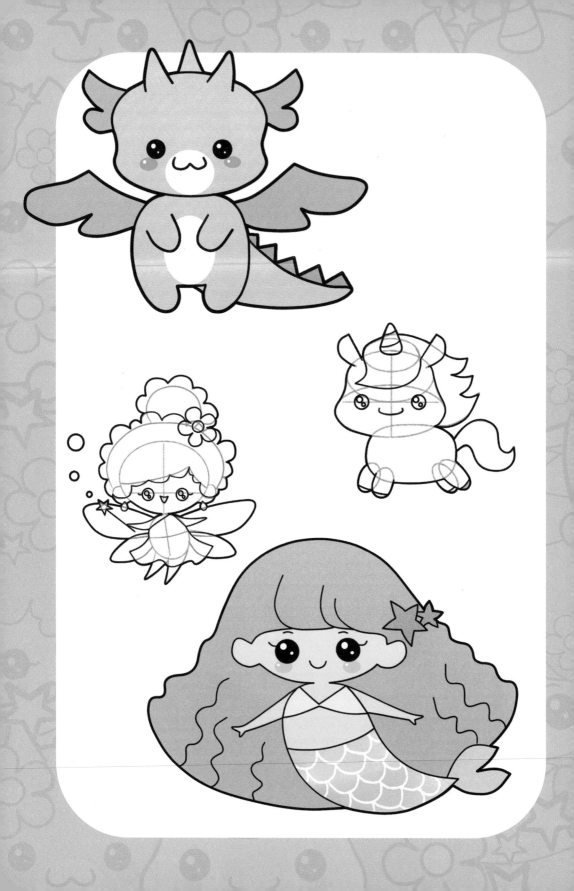

Kawaii Fantasy

Unicorn

Bring a magic touch to this colourful unicorn. Use ovals
and wavy lines to correctly position the legs.

1. Draw two overlapping
 ovals with a vertical line
 through the middle. The
 top oval is smaller than
 the bottom one.

2. Connect the sides of the
 ovals smoothly with
 inward-curving lines.

3. Draw a rounded rectangle below for the
 unicorn's body. Now add two pairs of ovals
 slightly overlapping each other below the body
 for the legs. Add short lines across the bottom
 of the legs to show hooves.

4. Add a horizontal line just under the top oval.
 Create big, round eyes with highlights, and a
 simple mouth in between. Add the ears.

5. For the mane, first, add a fringe in
 between the ears. Then, from the top
 of the fringe, draw a curvy, zigzag line
 down to the chin. Add a wavy tail.

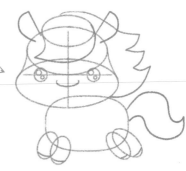

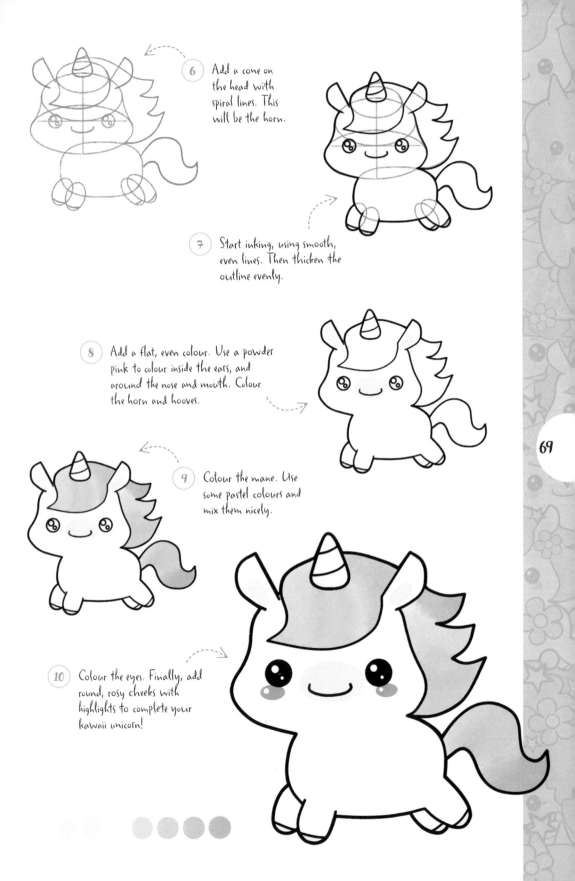

6 Add a cone on the head with spiral lines. This will be the horn.

7 Start inking, using smooth, even lines. Then thicken the outline evenly.

8 Add a flat, even colour. Use a powder pink to colour inside the ears, and around the nose and mouth. Colour the horn and hooves.

9 Colour the mane. Use some pastel colours and mix them nicely.

10 Colour the eyes. Finally, add round, rosy cheeks with highlights to complete your kawaii unicorn!

Fairy

Spread a little fairy dust with this cute fairy. Have fun with her curly hair and accessories, all created from simple shapes.

1 Draw a fat oval. Add a vertical line in its centre, then a horizontal line in the lower half. Add an angled vertical line below.

2 Add an oval around the vertical line for the body. Add thin, curved triangles for the arms and legs.

3 Add big, round eyes with highlights, a triangular mouth, and semi-circular ears.

4 Add a side-parted helmet shape to the head, and a curved line around the top as shown here. Then add a wavy line around it to show curly hair. Do the same above for the bun.

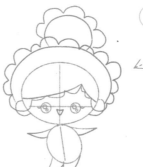

5 Draw a short, diagonal line across the left shoulder to show the top of the dress. Then trace a wavy hemline below.

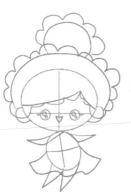

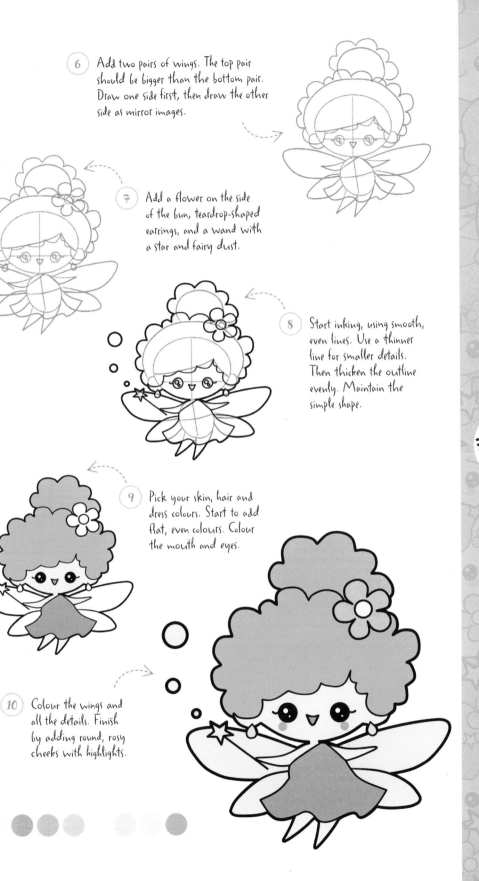

6. Add two pairs of wings. The top pair should be bigger than the bottom pair. Draw one side first, then draw the other side as mirror images.

7. Add a flower on the side of the bun, teardrop-shaped earrings, and a wand with a star and fairy dust.

8. Start inking, using smooth, even lines. Use a thinner line for smaller details. Then thicken the outline evenly. Maintain the simple shape.

9. Pick your skin, hair and dress colours. Start to add flat, even colours. Colour the mouth and eyes.

10. Colour the wings and all the details. Finish by adding round, rosy cheeks with highlights.

Dragon

Maintain the simple shapes in this cute baby dragon,
with soft horns and a simple, spiky tail.

1. Draw a vertical line. Then draw two overlapping ovals. The top oval should be deeper than the bottom one. Draw a horizontal line where the ovals meet.

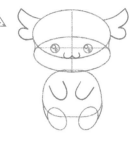

2. Connect the sides of the ovals smoothly with inward-curving lines. Then add a rounded square below.

3. Add U-shaped arms, and ovals for the legs. Connect the body to the legs smoothly with a curvy line.

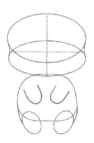

4. Draw round eyes with highlights, and a wide w-shaped mouth. Use the guidelines for positioning. Add the ears.

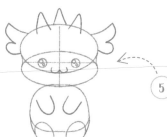

5. Add three pointy horns on top of the head – one in the centre, with two on each side.

6 Add the wings.

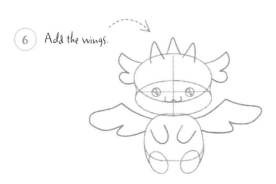

7 For the tail, first draw a thin wedge shape from the back of the body to the right. Then add a zigzag line along the top.

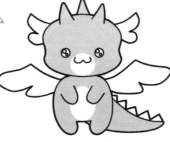

8 Start inking, using smooth, even lines. Then thicken the outline evenly.

9 Add a flat, even colour to the face, body, and main part of the tail.

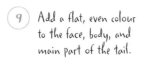

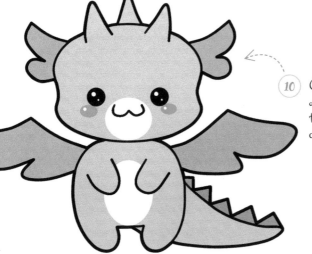

10 Colour the ears, wings, and spines of the tail a darker green. Colour the eyes. Finally, add round, rosy cheeks with highlights.

Mermaid

Draw this cute mermaid using lots of wavy lines,
from her tail and fin to her long, flowing hair.

(1) Draw a fat oval, then add a cross in its lower half.
Add a gently curving line from the bottom of the cross.

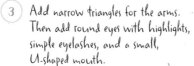

(2) Add a round leaf shape
around the curved line. This
will be the mermaid's body.

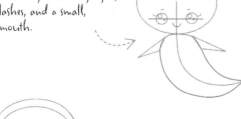

(3) Add narrow triangles for the arms.
Then add round eyes with highlights,
simple eyelashes, and a small,
U-shaped mouth.

(4) Add the ears, then add a helmet shape
for the fringe, as shown here. Add the
outline of very long hair.

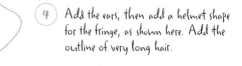

(5) Add tiny V-shapes to the tips of the arms for
the hands. Draw a slightly curvy cross on the
chest area for the bra top. Mark the waistline.
Add two smaller leaf shapes at the end of the
tail for the fin.

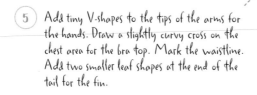

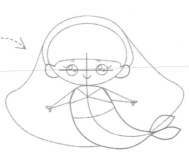

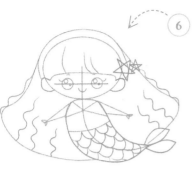

6 Add more detail. Use wavy lines to trace the outline of the wavy hair. Add two star-shaped hair clips, one smaller than the other, next to the ears. Add a fish-scale pattern to the tail.

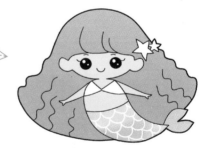

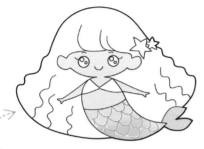

7 Start inking, using smooth, even lines. Then thicken the outline evenly.

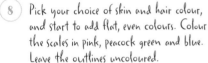

8 Pick your choice of skin and hair colour, and start to add flat, even colours. Colour the scales in pink, peacock green and blue. Leave the outlines uncoloured.

9 Colour the hair and eyes. Trace a white pen around the outlines of the scales.

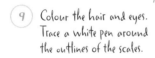

10 Colour the hair clips and bra top. To finish, add round, rosy cheeks with highlights.

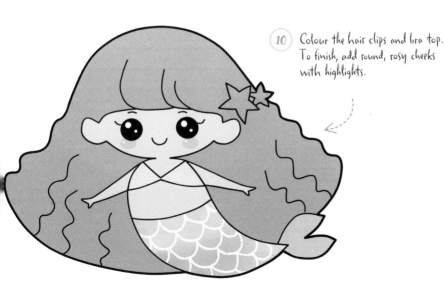

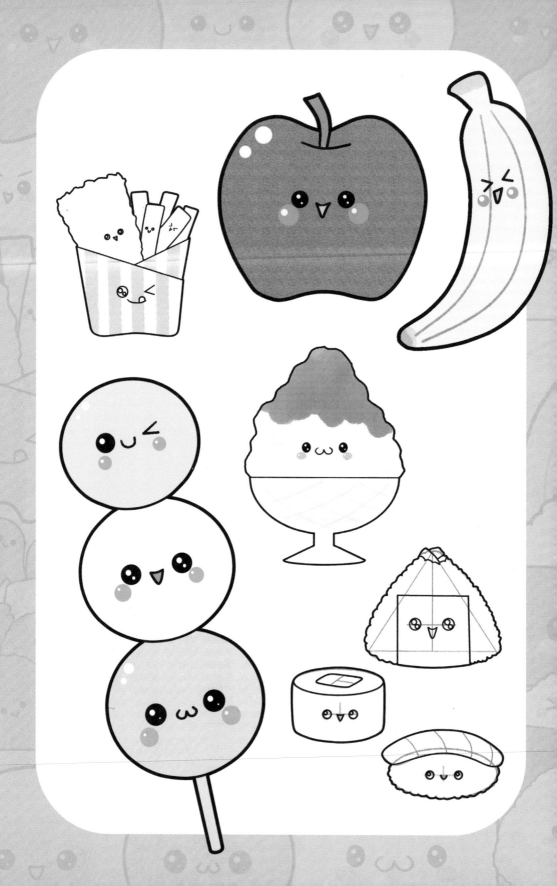

Kawaii Food

Sushi

Whip up two types of sushi in this kitchen masterclass – futomaki
(rolled sushi) and nigiri (topping on rice).

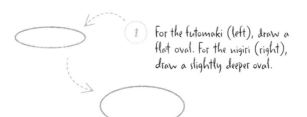

1 For the futomaki (left), draw a
 flat oval. For the nigiri (right),
 draw a slightly deeper oval.

2 For the futomaki, make the oval into
 a cylinder by adding three more lines.
 For the nigiri, add a sausage shape
 overlapping the top edge of the oval.
 This will be for the topping.

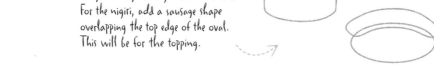

3 Add a cross in the
 centre of each sushi.

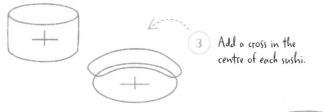

4 In each sushi, draw round eyes with highlights.
 Give the futomaki a triangular mouth, and
 the nigiri a simple, V-shaped mouth. Use the
 guidelines to position them.

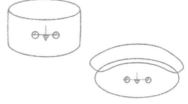

5 Add some details. For the futomaki, add
 a round-edged rectangle on top. Divide it
 in two, then divide the right half in two
 again. This will show the filling.

6 For the nigiri, add four short, curved lines along its length. Add an uneven outline around the bottom to show the rice texture.

7 Start inking, using smooth, even lines. Keep all the corners soft and round. Then thicken the outline evenly.

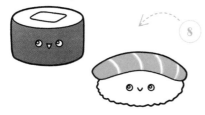

8 Start to add flat, even colours. For the futomaki, use a green-black colour for the seaweed part. For the nigiri, use salmon pink for the fish topping. Leave the lines white.

9 To show the fillings in the futomaki, add some colours inside the rectangle. Use soft yellow for omelette, green for vegetables, and a patchy red and white for crab sticks.

10 Colour the eyes and mouths. Add round, rosy cheeks with highlights.

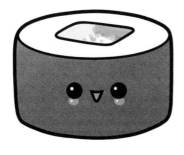

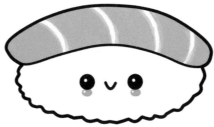

Fish and chips

This carton of fish and chips is perfect for the beach!
Choose softer colours for the food to make it look edible.

1 Draw a trapezium and then a triangle for the folded carton.

2 Round the bottom corners and curve the bottom line up.

3 Add three lines to show the fish in the carton. Then add an uneven outline to show the texture of the batter.

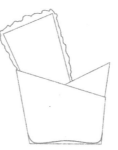

4 Add rectangular-shaped chips next to the fish, positioning them slightly randomly.

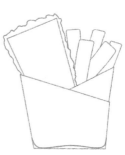

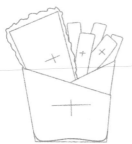

5 Draw crosses on the fish, chips, and the carton to help position the faces.

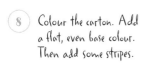

6　Add eyes and mouths. Try different facial expressions.

7　Start inking, using smooth, even lines. Use thinner lines for small details. Then thicken the outline evenly.

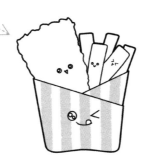

8　Colour the carton. Add a flat, even base colour. Then add some stripes.

9　Colour the fish and chips. Use a slightly darker colour on the left of the fish to add some shadow.

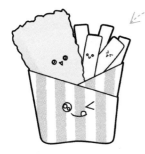

10　Colour the eyes and mouths. Add round, rosy cheeks. Finally, add little highlights to the cheeks to finish your kawaii fish and chips!

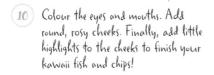

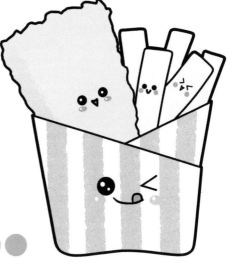

Bubble tea

Shake up this refreshing Taiwanese drink made from
blended tea, milk, fruit and chewy tapioca pearls.

1 Draw a vertical line. Then draw three very
flat ovals as shown here. The biggest oval is
at the top, the smallest at the bottom.

2 Connect the sides
to make a cup.

3 Add a short horizontal line in
the centre to help position the
face. Add the eyes and a
triangular mouth.

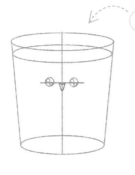

4 Add some circles in the
bottom of the cup. Some
should be overlapping
each other.

5 Add two small, flat ovals
at the top, as shown here.

6 Connect the sides of the small ovals and shape them into a straw.

7 Start inking, using smooth, even lines. Then thicken the outline evenly.

8 Start colouring. Graduate the colour from white to light brown inside the cup. Colour the bubbles.

9 Colour the lid. Add a diagonal lines design. Then colour the straw.

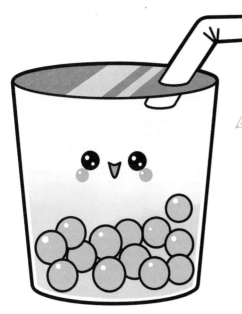

10 Colour the eyes and mouth. Add round, rosy cheeks. Finally, add little highlights on the cheeks and on some of the bubbles to finish your bubble tea.

Rice ball

Perfect for a quick and easy snack, this rice ball wrapped
in nori seaweed is as good to look at as it is to eat!

1 Draw a vertical line
and an almost
equilateral triangle.

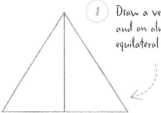

2 Add a rounder triangular
shape around it.

3 Add a square at the
bottom of the triangle.

4 Trace the outline of the triangle
with a fine, wavy line to show
the texture of rice.

5 Add a few flaky shapes to the
top of the triangle. This will be a
topping of some grilled salmon flakes.

6　Add a short, horizontal line in the centre of the square to position the face. Add the eyes with highlights and the mouth.

7　Start inking, using smooth, even lines. Then thicken the outline evenly.

8　Start to add flat, even colours. Start with the seaweed. Use a green-black colour.

9　Use salmon pink to colour the salmon flakes. Colour the eyes and mouth.

10　Add round, rosy cheeks. Then add little highlights on the cheeks to finish your kawaii rice ball!

Bento

This bento lunch box is packed full of ingredients
and bursting with colour and taste!

① Shape the lunch box. Draw a
round-cornered rectangle. Then
add depth to the bottom.

② Draw two very round triangles on
the left of the box. They will be rice
balls, so put a square of nori seaweed
on one of them.

③ Draw two overlapping
circles to the side. They
will be meatballs.

④ Draw a smaller circle to the left of the
meatballs (1) and a medium-sized one
in the bottom-right corner (2). Draw a
round-cornered rectangle for a slice of omelette
above and overlapping a meatball (3).

⑤ Add some details. The circle to the left of the
meatballs (1) is broccoli, so trace a curly outline
with a stem at the bottom. The circle bottom right
(2) is a tomato, so add a stalk. Above the tomato,
add another broccoli by drawing a curly line.

6 Draw a wavy line over the top of the box. Then draw two small circles below. Add a curvy zigzag to one of the circles to form octopus-shape frankfurters.

7 Draw crosses in the centre of each ingredient. Vary the angles of the crosses. Then add eyes and mouths. Use a variety of facial expressions.

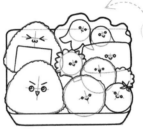

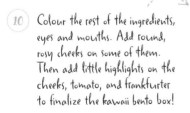

8 Start inking, using smooth, even lines. Use thinner lines for small details. Then thicken the outlines evenly.

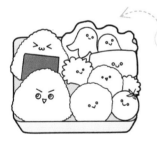

9 Start to add flat, even colours. For the omelette, add a white spiral on it.

10 Colour the rest of the ingredients, eyes and mouths. Add round, rosy cheeks on some of them. Then add little highlights on the cheeks, tomato, and frankfurter to finalize the kawaii bento box!

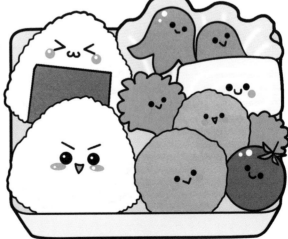

Curry

A simple plate of curry becomes kawaii when the rice has a sleeping
face and the curry sauce is shaped like a duvet!

1. Draw an oval
for the plate.

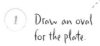

2. Add a smaller oval inside
and to the left for the rice.

3. Add a big crescent shape next to and slightly
overlapping the smaller oval. This will be
the curry sauce. Add a small bean shape
to the top left for the pickle.

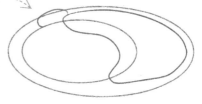

4. Trace a wavy line around the
outline of the small oval to
show the texture of the rice.

5. Trace a zigzag line around the small
bean shape for the pickles. Add some
round shapes to the right. These will
be ingredients in the curry sauce.

88

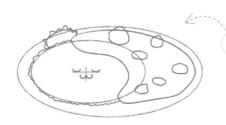

6 Add a cross in the middle of the rice. Add eyes and a tiny, w-shaped mouth.

7 Start inking, using smooth, even lines. Then thicken the outline evenly.

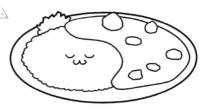

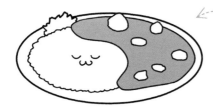

8 Add flat, even colours. Start with the sauce.

9 Colour the ingredients. They are usually meat, carrot and potato, so choose the colour accordingly. Add a reddish colour to the pickle to show a Japanese pickle called fukujinzuke, which typically accompanies curries.

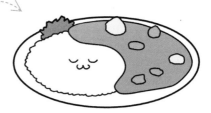

10 Add round, rosy cheeks, then add little highlights to finish.

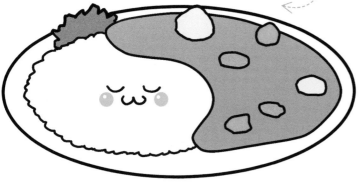

Ice cream

Like many foods in Japan, you can buy kawaii ice cream fashioned into all sorts of cute animal shapes: but even a plain ice cream cone can become kawaii with some cute faces.

1) Draw a tilted triangle and a fat oval. They should overlap slightly.

2) Add two more overlapping ovals. Add a narrower triangle on the side.

3) Add guides for the edges of the melting ice cream, the fan wafer and the cone wrapper.

4) Erase the overlapping guidelines. Add crosses in the centre of each scoop to help position the faces.

5) Add eyes and mouths in different expressions, and add some sprinkles.

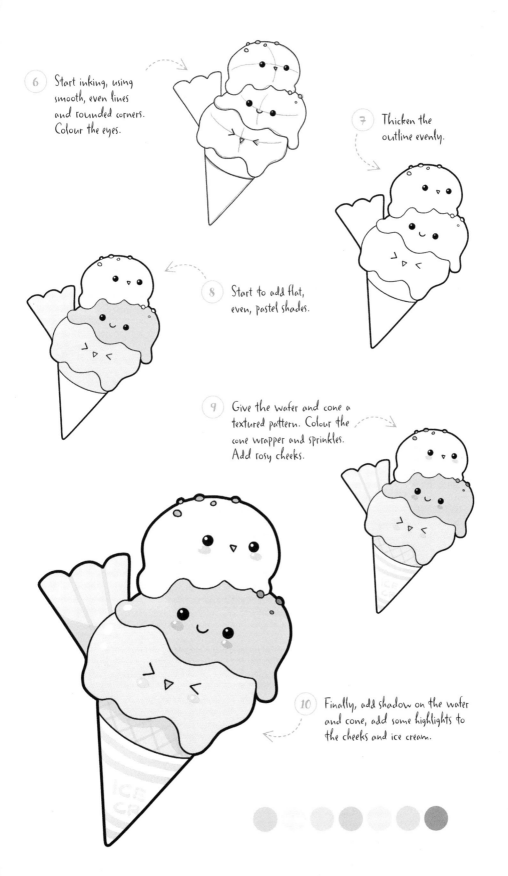

6 Start inking, using smooth, even lines and rounded corners. Colour the eyes.

7 Thicken the outline evenly.

8 Start to add flat, even, pastel shades.

9 Give the wafer and cone a textured pattern. Colour the cone wrapper and sprinkles. Add rosy cheeks.

10 Finally, add shadow on the wafer and cone, add some highlights to the cheeks and ice cream.

ICE
CR

Fruit

Use ovals, crescent shapes and smooth, even lines
to draw a shiny red apple and a sleeping banana.

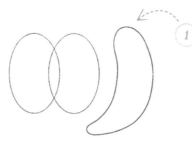

1. Draw two tall ovals slightly overlapping each other. Then, draw a fat crescent shape with rounder top.

2. Connect and shape the two ovals on the top, sides and bottom.

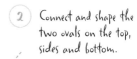

3. Add stalks to the apple and banana.

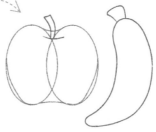

4. Add a few lines on the banana.

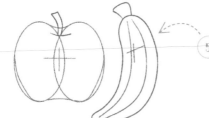

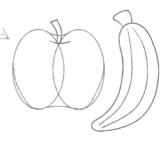

5. Add crosses to mark the position of the faces. Draw the banana's cross at a slight angle.

6 Add eyes and mouths.
Try different expressions.

7 Start inking, using smooth, even
lines. Then thicken the outline
evenly. Do not ink the lines on
the banana yet.

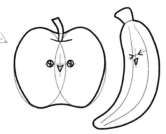

8 Start to add colour
in flat, even shades.

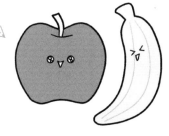

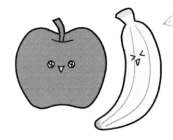

9 Colour the stalks. Trace
brown lines on the banana,
and add some brown to
the top and bottom.

10 Colour the eyes and mouth.
Add round, rosy cheeks. Then
add little highlights on the
cheeks and on the apple.

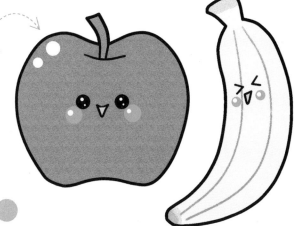

Mochi

Mochi is a Japanese rice cake, traditionally eaten at
Japanese New Year and other special occasions.

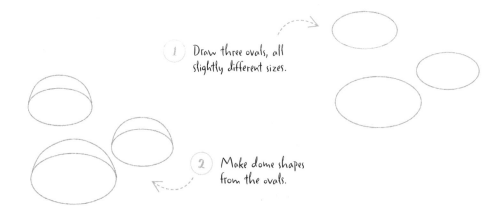

1. Draw three ovals, all
 slightly different sizes.

2. Make dome shapes
 from the ovals.

3. Shape the bottom line
 of each dome, bringing
 it slightly inwards.

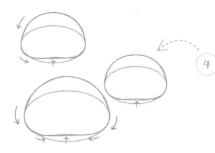

4. Shape the rest of the domes,
 making them really smooth and
 round, with no pointy parts.

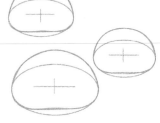

5. Add crosses in the lower
 half of each dome to help
 position the faces.

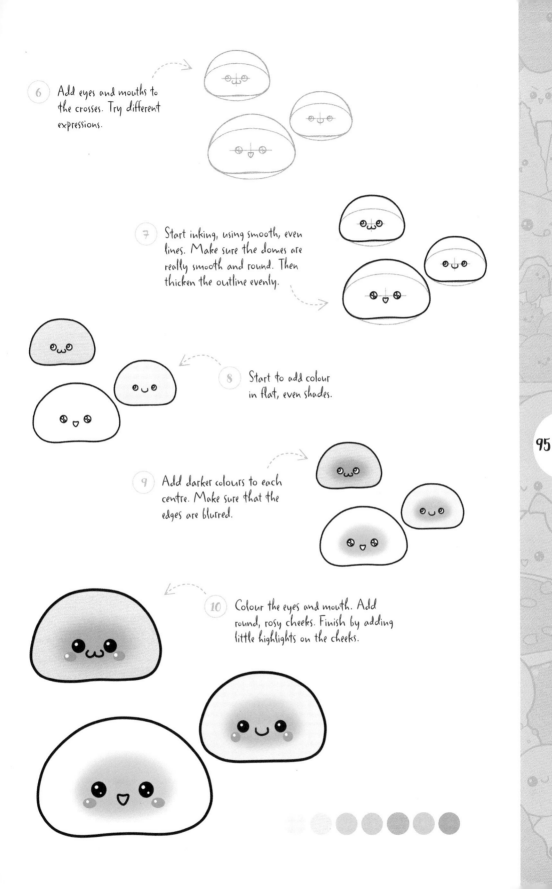

6 Add eyes and mouths to the crosses. Try different expressions.

7 Start inking, using smooth, even lines. Make sure the domes are really smooth and round. Then thicken the outline evenly.

8 Start to add colour in flat, even shades.

9 Add darker colours to each centre. Make sure that the edges are blurred.

10 Colour the eyes and mouth. Add round, rosy cheeks. Finish by adding little highlights on the cheeks.

Dango

Dango are sweet, chewy Japanese dumplings made from rice flour, usually
served on a skewer. These kawaii dango are shouting, 'Eat me!'

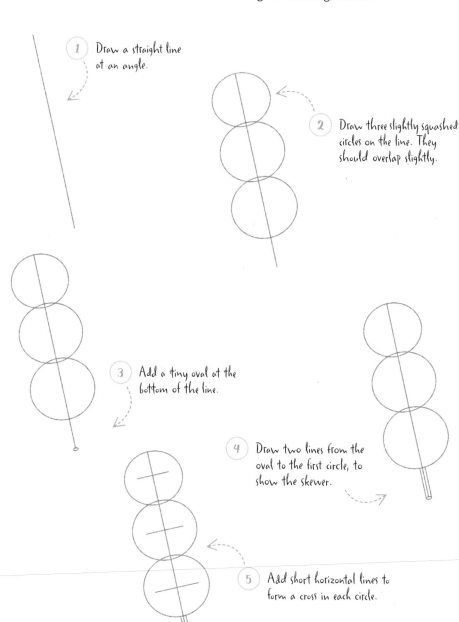

1 Draw a straight line
 at an angle.

2 Draw three slightly squashed
 circles on the line. They
 should overlap slightly.

3 Add a tiny oval at the
 bottom of the line.

4 Draw two lines from the
 oval to the first circle, to
 show the skewer.

5 Add short horizontal lines to
 form a cross in each circle.

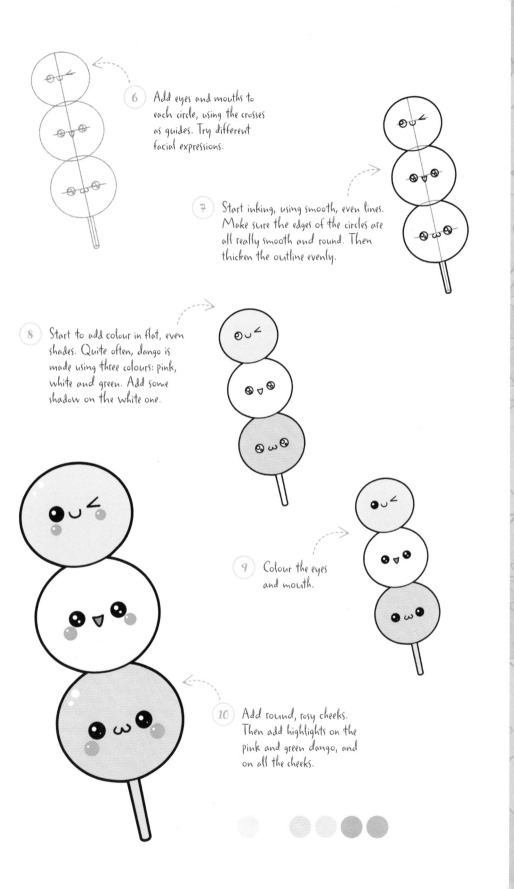

6. Add eyes and mouths to each circle, using the crosses as guides. Try different facial expressions.

7. Start inking, using smooth, even lines. Make sure the edges of the circles are all really smooth and round. Then thicken the outline evenly.

8. Start to add colour in flat, even shades. Quite often, dango is made using three colours: pink, white and green. Add some shadow on the white one.

9. Colour the eyes and mouth.

10. Add round, rosy cheeks. Then add highlights on the pink and green dango, and on all the cheeks.

Kakigori

Kakigori is a traditional Japanese shaved ice dessert, topped with a sweet syrup. Choose from strawberry, lemon, plum or blue raspberry.

1. Draw a vertical line. Add a flat oval at the bottom.

2. Connect the oval to the vertical line using two lines.

3. Add a small rectangle on top.

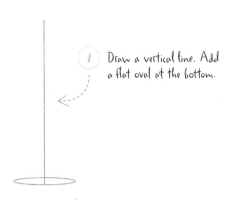

4. Add a big oval on top. Then draw a horizontal line in the middle.

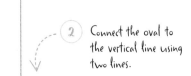

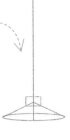

5. Draw two lines to make a triangle, from the ends of the horizontal line to the top of the vertical line. Use a wavy line to show the edges of the shaved ice.

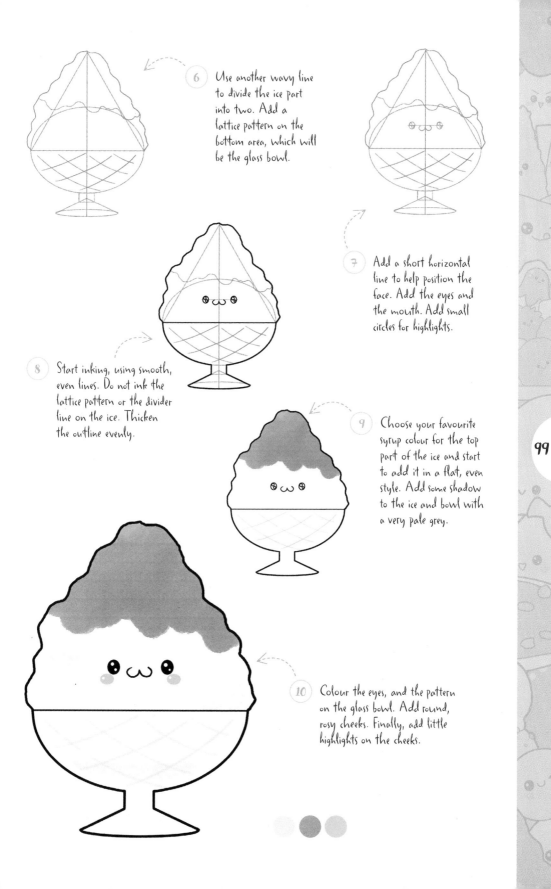

6. Use another wavy line to divide the ice part into two. Add a lattice pattern on the bottom area, which will be the glass bowl.

7. Add a short horizontal line to help position the face. Add the eyes and the mouth. Add small circles for highlights.

8. Start inking, using smooth, even lines. Do not ink the lattice pattern or the divider line on the ice. Thicken the outline evenly.

9. Choose your favourite syrup colour for the top part of the ice and start to add it in a flat, even style. Add some shadow to the ice and bowl with a very pale grey.

10. Colour the eyes, and the pattern on the glass bowl. Add round, rosy cheeks. Finally, add little highlights on the cheeks.

99

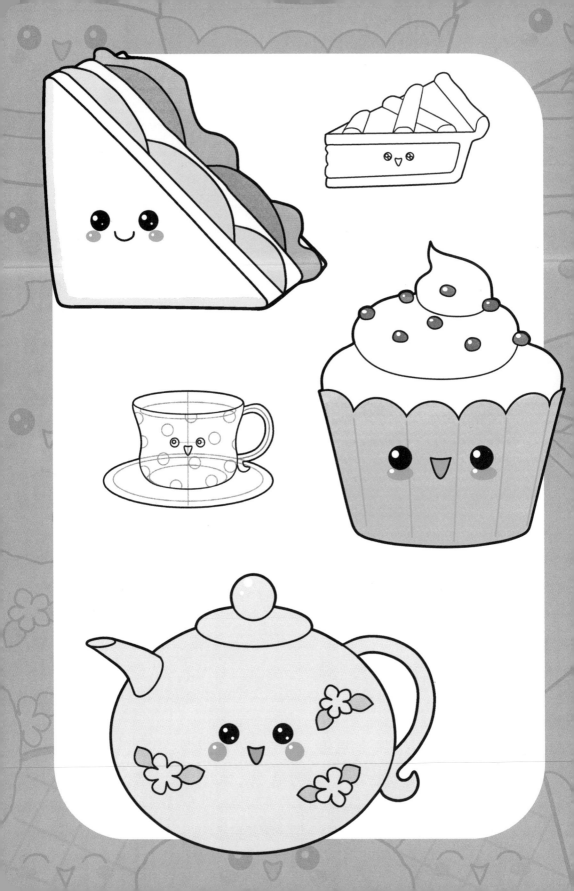

Tea Party

Teacup

Time for tea! Decorate this teacup in spots, or choose your own pattern.

1. Draw a vertical line. Then draw two flat ovals, as shown here. The top oval is wider than the bottom one.

2. Add two more oval lines around the bottom oval to form the edges of the saucer.

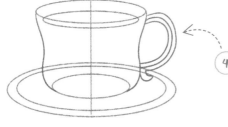 ... wait

3. Connect the sides of the first two ovals with curvy lines to make the shape of the cup. Then add another oval just under the top oval. This will be the surface of tea inside.

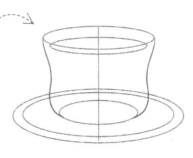

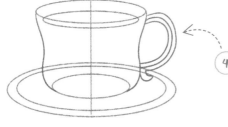

4. Add the handle. Draw the central line first, then add the lines on the outside.

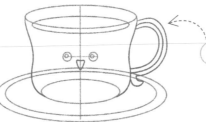

5. Add a short horizontal line in the centre of the cup to help position the face. Add the eyes and mouth.

6 Add a dotty pattern to the cup with small circles.

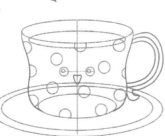

7 Start inking, using smooth, even lines. Then thicken the outline evenly. Do not ink the line for the tea surface, dots, or the inner line of the saucer.

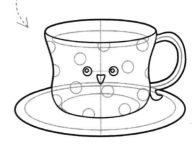

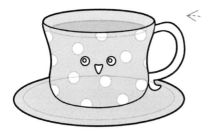

8 Start to add colour in flat, even shades. First, colour the tea area, then the cup and saucer. Leave the dots as white.

9 Colour the handle and the inner line on the saucer.

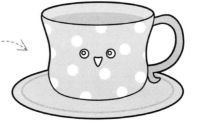

10 Colour the eyes and mouth, leaving the highlights in the eyes white. Add round, rosy cheeks. Then finish by adding little highlights on the cheeks.

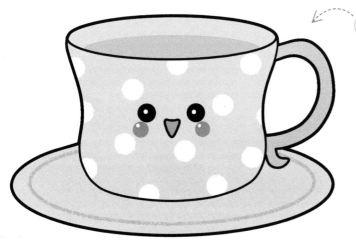

Teapot

Big ovals, small ovals, flat ovals and curves – connect them
all to make this cute teapot.

(1) Draw a deep oval.

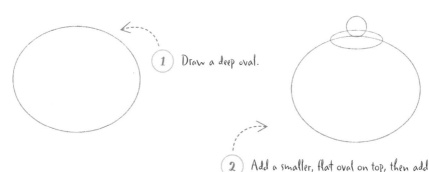

(2) Add a smaller, flat oval on top, then add
a circle above. They form the teapot's lid.

(3) For the spout: first, draw a small, tilted oval (1).
Then draw another small oval at the point where
the end of the spout will be (2). Connect the
two ovals with curved lines (3).

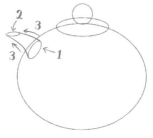

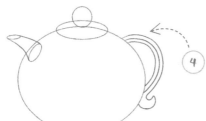

(4) Add the handle. Draw the central line
first, then add the lines on the outside.

(5) Add a cross to the centre of the pot
to help position the face. Add the
eyes with highlights and a mouth.

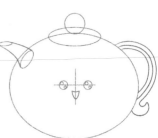

6 Add your choice of pattern.
This one has flowers and leaves.

7 Start inking, using smooth, even lines.
Then thicken the outline evenly.

8 Add a flat, even
colour to the teapot.

9 Colour the patterns.

10 Colour the eyes and
mouth, and add round,
rosy cheeks. Then add
little highlights on the
cheeks and the top of
the lid to finish your
kawaii teapot!

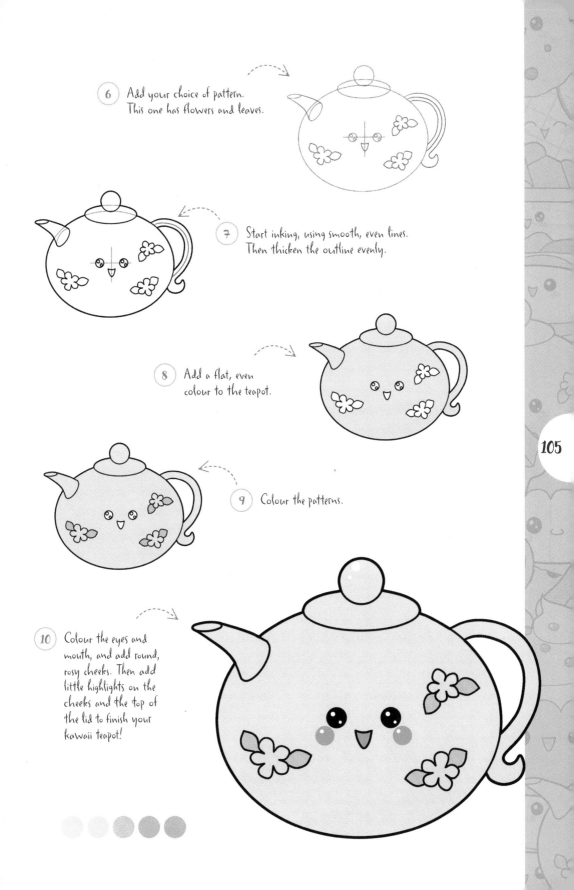

Sandwich

Combine straight lines with curves to make this juicy sandwich,
with layers of ham, cheese, tomato and lettuce.

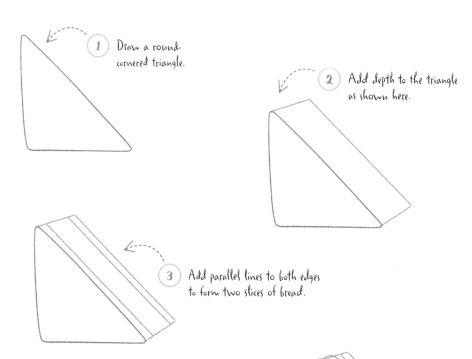

1. Draw a round-cornered triangle.

2. Add depth to the triangle as shown here.

3. Add parallel lines to both edges to form two slices of bread.

4. Start to add the fillings. Draw three curves for slices of ham. Then add a loose line for cheese.

5. Add more fillings. Behind the cheese, add two curves for tomato, and then a wavy line for lettuce. This will cover most of the bread area, but make sure some still shows.

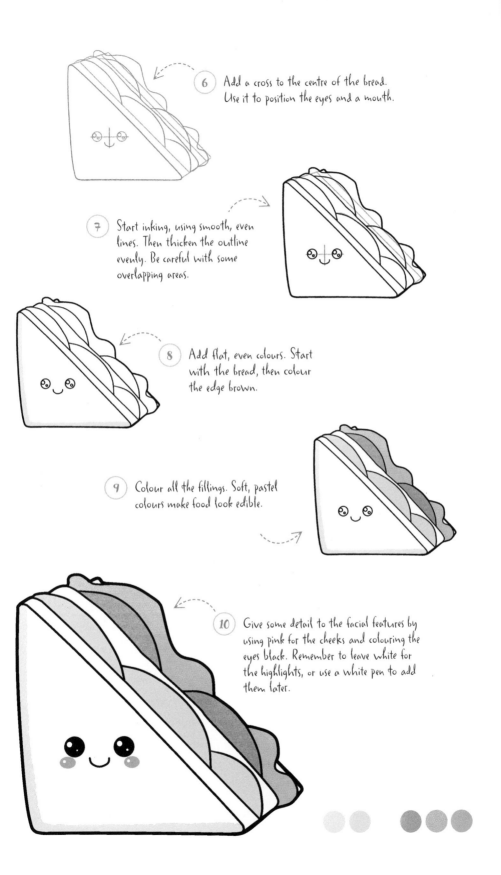

6 Add a cross to the centre of the bread. Use it to position the eyes and a mouth.

7 Start inking, using smooth, even lines. Then thicken the outline evenly. Be careful with some overlapping areas.

8 Add flat, even colours. Start with the bread, then colour the edge brown.

9 Colour all the fillings. Soft, pastel colours make food look edible.

10 Give some detail to the facial features by using pink for the cheeks and colouring the eyes black. Remember to leave white for the highlights, or use a white pen to add them later.

Cupcake

Turn ovals and oblongs into a cupcake topped with
swirling icing, finished with sweet sprinkles.

1. Draw a vertical line and add
 two flat oval shapes. Connect
 the sides of the ovals to
 form the shape of the cup.

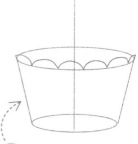

2. Add a wavy line along
 the top of the cup.

3. Add three oblong shapes,
 one above the other, slightly
 overlapping. The bottom one
 should fit into the cup, and
 each oblong above is smaller.
 These will be the icing.

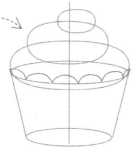

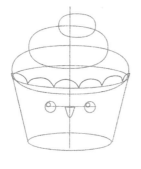

4. Add a short horizontal line in the centre of the
 cup to help position the face. Add the eyes and
 a triangular mouth. Add a small circle in the
 top left of each eye for highlights.

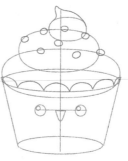

5. Add a pointy tip to the top of
 the icing, and add some small,
 round shapes for the sprinkles.

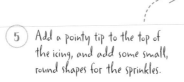

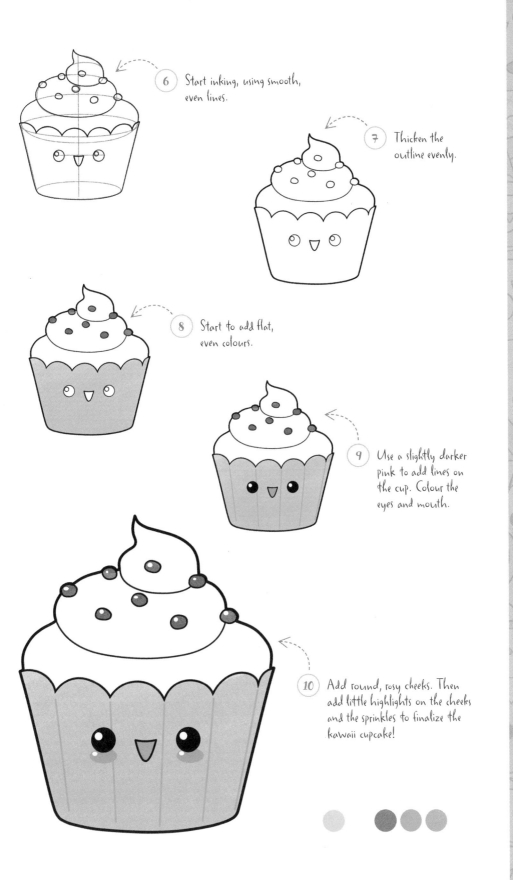

6 Start inking, using smooth, even lines.

7 Thicken the outline evenly.

8 Start to add flat, even colours.

9 Use a slightly darker pink to add lines on the cup. Colour the eyes and mouth.

10 Add round, rosy cheeks. Then add little highlights on the cheeks and the sprinkles to finalize the kawaii cupcake!

Muffin

This white chocolate and raspberry muffin is such fun to draw.
It starts just like a cupcake.

1 Draw a vertical line and add two flat oval shapes, one on the bottom of the line and the other, slightly bigger, in the middle.

2 Connect the sides of the ovals to form the shape of the cup.

3 Add a wavy line along the top of the cup.

4 Draw an oval on top of the cup, then use it as a base to add a mushroom-shaped top.

5 Add a short horizontal line in the centre of the cup to help position the face. Add the eyes and a U-shaped mouth. Add small circles in each eye for highlights.

6 Add some shapes for the toppings. The larger, more square ones are white chocolate chunks and the smaller ones are raspberries.

7 Start inking, using smooth, even lines. Then thicken the outline evenly.

8 Start to add flat, even colours to the cake top and base.

9 Add colour to the raspberries. Use a slightly darker colour to add lines on the cup.

10 Colour the eyes and mouth. Then add round, rosy cheeks. Finally add little highlights on the cheeks to finish the kawaii muffin!

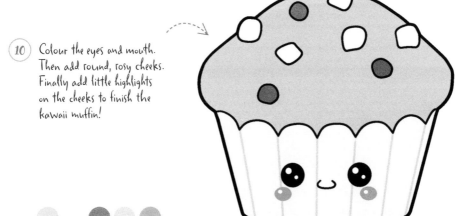

Cookies

These cookies look so good they've already
had a bite taken out!

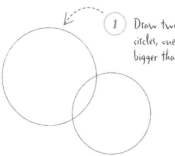

1. Draw two overlapping circles, one slightly bigger than the other.

2. On the bigger circle, trace the edge with a fine, uneven line to give it some texture. To the top left, add a bite mark and some crumbs.

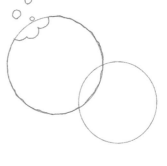

3. Add crosses in the centre of each circle.

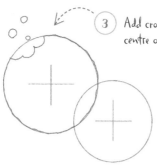

4. Use the crosses to position the eyes and mouths. Try different facial expressions.

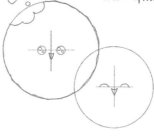

5. Add some round shapes on the bigger circle for chocolate chips. Position a couple of them on the edge.

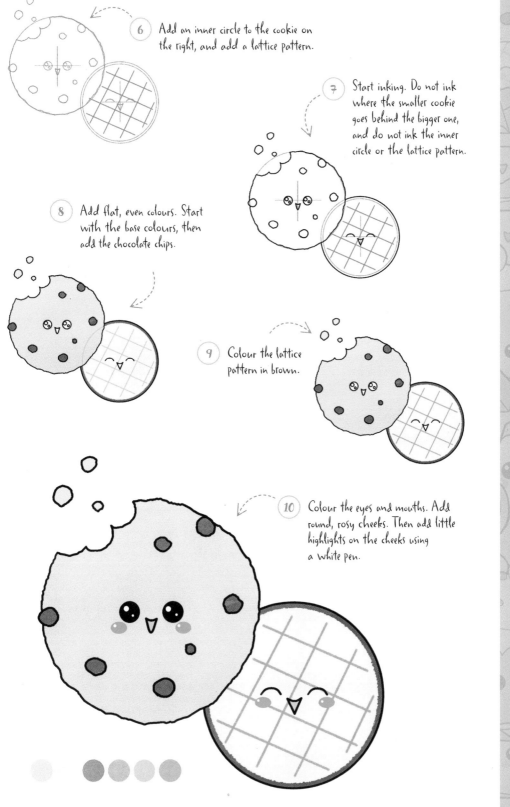

6) Add an inner circle to the cookie on the right, and add a lattice pattern.

7) Start inking. Do not ink where the smaller cookie goes behind the bigger one, and do not ink the inner circle or the lattice pattern.

8) Add flat, even colours. Start with the base colours, then add the chocolate chips.

9) Colour the lattice pattern in brown.

113

10) Colour the eyes and mouths. Add round, rosy cheeks. Then add little highlights on the cheeks using a white pen.

Macaroon

Build this macaroon using uneven tube shapes. This macaroon
is lavender-flavoured so a milky pale purple is used.

1. Draw an oval. Then draw a vertical line from the top.

2. Draw another oval the same size and same shape, just below the first.

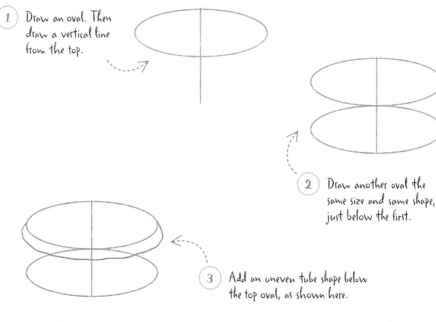

3. Add an uneven tube shape below the top oval, as shown here.

4. Add another slightly narrower tube shape underneath, with a more even line.

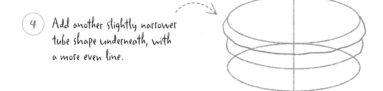

5. Add a second slightly uneven tube shape, just like the one in step 3.

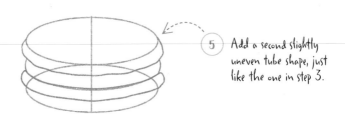

6 Add a short horizontal line to help position the eyes and mouth. Add small circles in the eyes for highlights.

7 Start inking, using smooth, even lines. Then thicken the outline evenly.

8 Start to add flat, even colours. Add a darker purple with a slightly uneven stroke to the biscuit edges.

9 Use an even darker purple to colour the cream area.

10 Colour the eyes and mouth. Add round, rosy cheeks. Giving the macaroon rosy cheeks completes the happy expression.

Apple pie

Perfect your pastry skills with this slice of perfectly browned apple pie,
warm and straight from the oven.

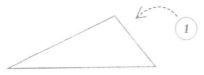

(1) Draw a tilted, slightly thin triangle.

(2) Add three lines to turn the triangle into a wedge-shaped slice of pie. The right vertical edge should be angled slightly inwards.

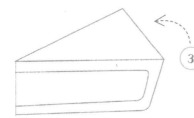

(3) Add a rectangle inside the slice as shown here. This is for the filling.

(4) Add a tube shape on the right edge to form the edge of the pastry.

(5) On top of the slice, arrange some tube shapes to show the lattice decoration.

6 Add some uneven rectangles to the filling area, similar to a loose bricks pattern.

7 Add a cross to the centre of the filling area. Use it to position the eyes and a mouth. Add a couple of highlights on each eye.

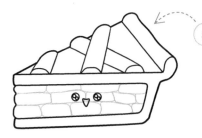

8 Start inking, using smooth, even lines. Then thicken the outline evenly. Do not ink the filling area.

9 Start to add flat, even colours. Use a darker brown on the tops of the pastry tubes to show browning in an oven. Use a darker brown for the lines in the filling area.

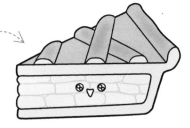

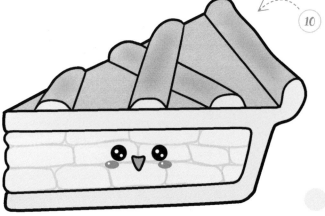

10 Colour the eyes and mouth, and add round, rosy cheeks. Finish by adding little highlights on the cheeks.

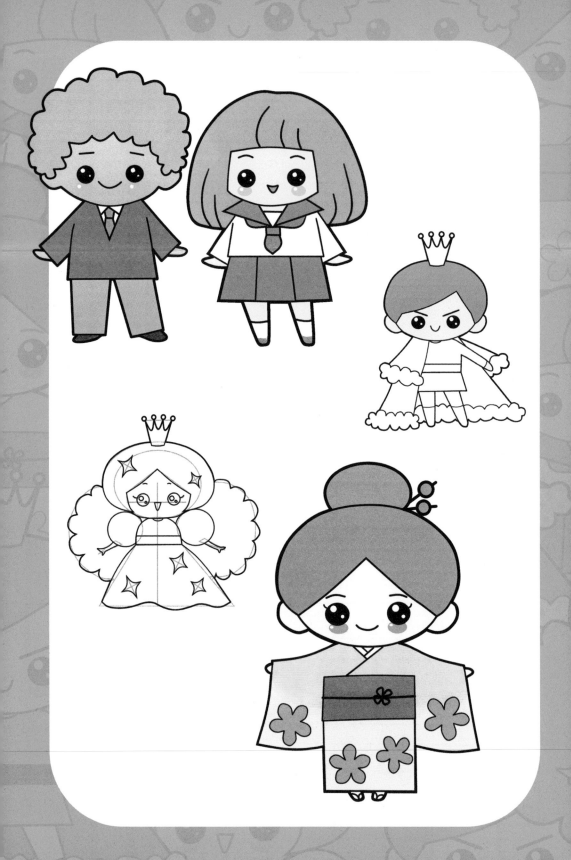

Kawaii People

Princess

A jewelled crown, golden sparkles and lots of pink hair
make this princess the belle of the ball!

1. Draw an oval, then add an elongated cross in its lower half.

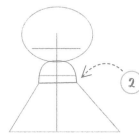

2. Add a dome shape for the body, with a small rectangle for the sash. Draw a trapezium below that for the skirt.

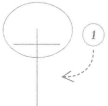

3. Draw two circles on the sides, with thin triangles for the arms. Use the cross to place another two small circles and a triangle for the eyes and mouth.

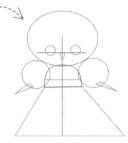

120

4. Add a centre-parted helmet shape to the head as shown here. Add a trapezium on top for the crown. Then add big semi-circles on both sides for the hair.

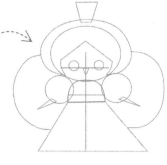

5. Add highlights in both eyes. Then add simple eyelashes and eyebrows. Shape the hands.

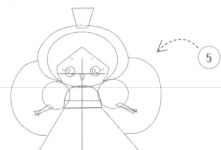

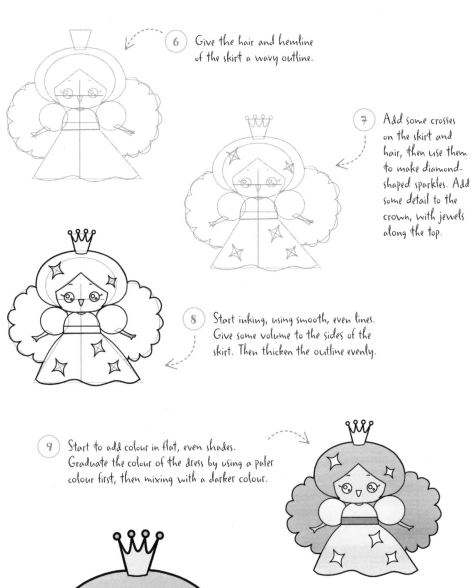

6 Give the hair and hemline of the skirt a wavy outline.

7 Add some crosses on the skirt and hair, then use them to make diamond-shaped sparkles. Add some detail to the crown, with jewels along the top.

8 Start inking, using smooth, even lines. Give some volume to the sides of the skirt. Then thicken the outline evenly.

9 Start to add colour in flat, even shades. Graduate the colour of the dress by using a paler colour first, then mixing with a darker colour.

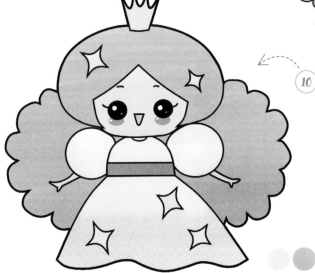

10 Colour the eyes, sparkles and crown. Add a pale-pink mouth and round, rosy cheeks. Finish by adding highlights to the cheeks to complete your kawaii princess!

Prince

This rosy-cheeked prince with his fur-lined cloak and jewelled
crown is a perfect match for your princess.

1. Draw an oval,
then add an
elongated cross in
its lower half.

2. Add a dome shape under the
oval, with a small rectangle
below. Draw a shallow
trapezium under this to make
the prince's body and belt.

3. Draw cone shapes for the right arm
and legs, with short, horizontal lines
to mark the hand and boots. Use
the cross to place the eyes with
highlights, eyebrows, mouth and ears.

4. Add a side-parted helmet
shape to the head as shown
here, with a small trapezium
on top for the crown.

5. Draw a cloak using four triangle
shapes (1–4). Parts (1) and (2)
of the cloak will cover half of
the body.

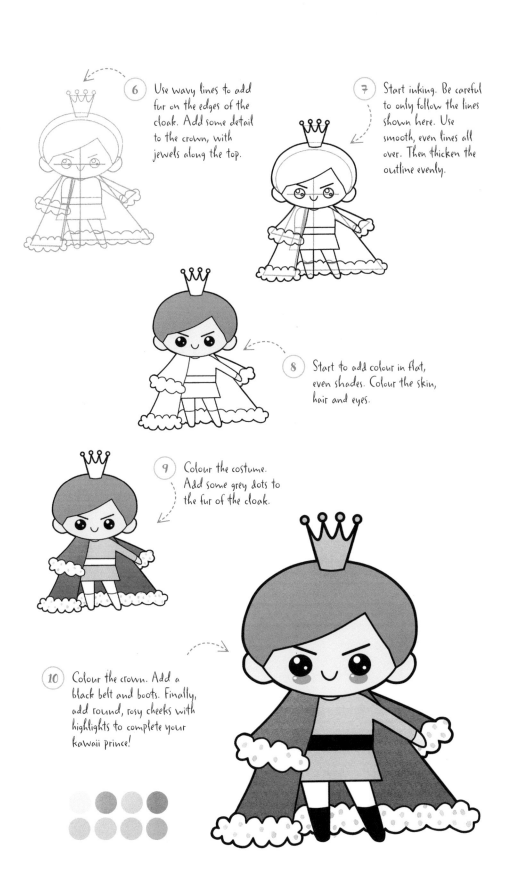

6 Use wavy lines to add fur on the edges of the cloak. Add some detail to the crown, with jewels along the top.

7 Start inking. Be careful to only follow the lines shown here. Use smooth, even lines all over. Then thicken the outline evenly.

8 Start to add colour in flat, even shades. Colour the skin, hair and eyes.

9 Colour the costume. Add some grey dots to the fur of the cloak.

10 Colour the crown. Add a black belt and boots. Finally, add round, rosy cheeks with highlights to complete your kawaii prince!

School kids

A school tie and sailor collar in matching colours add the finishing touches to these school kids, ready for their first day.

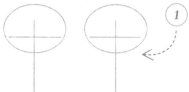

1. Draw an oval, then add an elongated cross in its lower half. Repeat this to the right of your original guide.

2. Under the left oval, add an oblong-shaped body, with two rectangles below for the trousers, one straight and the other slightly angled. Under the right oval, add a shorter, dome-shaped body. Add three rectangles below to form a pleated skirt.

3. Use the guidelines to position the facial features. Draw the arms, legs, hands and feet. Add ears to the head on the left.

4. Add helmet shapes to the heads as shown here.

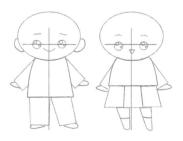

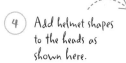

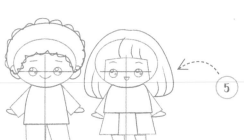

5. Trace a wavy outline for the boy's hair, and some flowing lines to the girl's.

6 Add detail to the clothes. For the boy, add a V-shape under the chin, then add a collar and tie. For the girl, add a smaller V-shape under the chin, then add two triangular shapes on the sides to form a sailor collar. Add a tied scarf below.

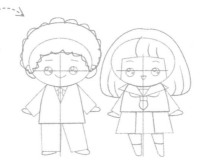

7 Start inking. Try to use smooth, even lines all over. Then thicken the outline evenly.

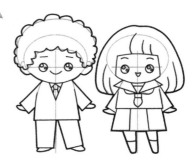

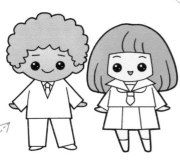

8 Pick your choice of skin and hair colours. Start to add colour in flat, even shades.

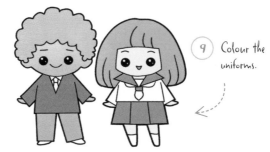

9 Colour the uniforms.

10 Use a matching colour for the tie and scarf. Add dark grey to the boy's shoes and the toes of the girl. Finally, add round, rosy cheeks with highlights to complete your kawaii school kids!

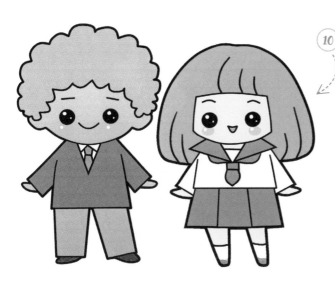

Kimono girl

Transform a simple oval and oblong into a pretty kimono girl,
complete with a decorated obi belt and clog sandals.

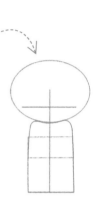

1. Draw an oval,
then add a cross
in its lower half.

2. Add an oblong below
the oval, with a smaller
rectangle in the middle.
These will be the body
and obi belt.

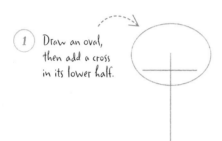

3. Add rectangular shapes on both sides
of the body, with tiny semi-circles for
the hands and feet. Add facial features
and ears, using the guidelines to check
the balance.

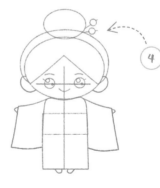

4. Add a centre-parted helmet
shape to the head as shown
here. Add an oval on top
for the bun. Draw two
small lines with circles for
hair ornaments.

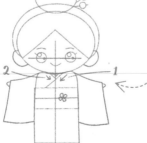

5. Add detail to the kimono. Draw the outer
neckline following the numbers shown. Repeat for
the inner neckline. Add a horizontal line in the
middle of the belt, with a flower to one side. For
the feet, add tiny V-shapes for sandals.

126

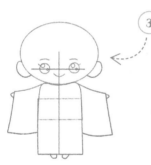

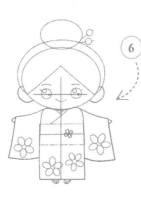

6 Add flowers using oval shapes arranged around a circle.

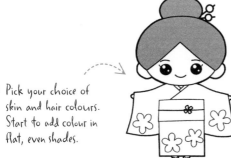

7 Start inking using smooth, even lines. Use slightly thinner lines for the pattern. Then thicken the outline evenly.

8 Pick your choice of skin and hair colours. Start to add colour in flat, even shades.

9 Colour the kimono. Graduations of colours are often used for kimonos. Start with a paler colour and gradually mix with darker colours.

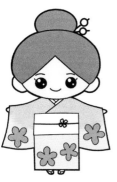

10 Colour the hair accessories and belt. Add round, rosy cheeks, and finish with cute, white highlights.

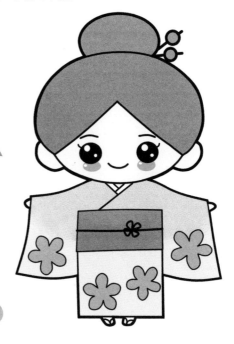

About the Artist

Chie Kutsuwada is a UK-based Japanese manga creator and illustrator. She creates stories as well as illustrations, such as 'King of a Miniature Garden' in *The Mammoth Book of Best New Manga II*, and Moonlight in *The Mammoth Book of Best New Manga III*, which was shortlisted in the Manga Jiman competition organized by the Japanese Embassy. She has also worked on Shakespeare's *As You Like It* and Musashi Miyamoto's *The Book of Five Rings*, and contributed to the bi-monthly illustrated column Mondo Manga for Mainichi Weekly. She has been teamed up with an author, Julian Sedgwick, to publish *Tsunami Girl*, and is planning the next book, too. Chie also attends many manga-related events in and out of the UK and runs manga workshops at schools, libraries and museums including the British Museum, the Royal Academy of Arts and the Barbican. She has also worked on projects for Channel 4 and CNN.

If you'd like to find out more information or to see further examples of Chie's work, you can visit her at chitangarden.wix.com/chiekutsuwada; facebook.com/chitangarden; on Instagram @mcmc69; and on Twitter @chitanchitan.

Acknowledgements

A big thank you to my family in Japan, especially to my brave dad. He has been in hospital so long now but tries to encourage me to work hard. And thanks to my housemate, who was patient with me when I was trying to juggle my life, my work and family issue. Also, I am very grateful to Abbie, Polly and the team at The Bright Press. Thank you very much for another wonderful opportunity and for being supportive and patient with me as always!